A–Z

OF

EXETER

PLACES - PEOPLE - HISTORY

Chris Hallam

AMBERLEY

First published 2019

Amberley Publishing
The Hill, Stroud, Gloucestershire, GL5 4EP
www.amberley-books.com

Copyright © Chris Hallam, 2019

The right of Chris Hallam to be identified as
the Author of this work has been asserted in
accordance with the Copyrights, Designs and
Patents Act 1988.

ISBN 978 1 4456 8964 7 (print)
ISBN 978 1 4456 8965 4 (ebook)

British Library Cataloguing in Publication Data.
A catalogue record for this book is available
from the British Library.

Typesetting by Aura Technology and Software
Services, India. Printed in Great Britain.

Contents

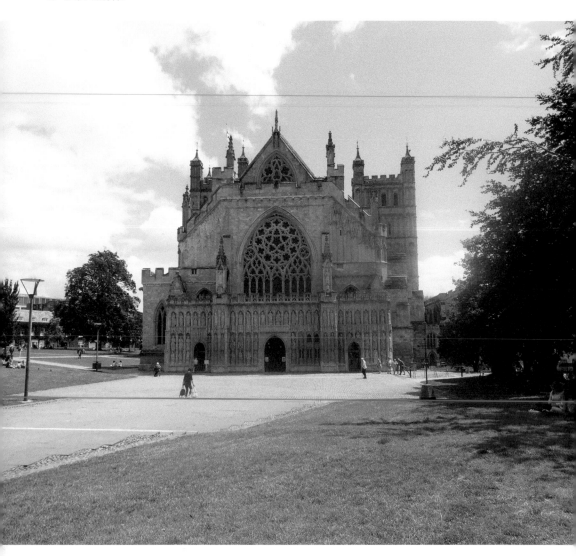

Exeter Cathedral.

Introduction

If the past is a foreign country, as L. P. Hartley said, then the Exeter of the past is an exotic foreign land indeed – exciting, interesting and sometimes dangerous.

Once one of the most important cities in England, Exeter remains one of the most pleasant; busy, vibrant and the ideal size – neither too small nor too large. It has a modern dynamic economy including an airport, university and several railway stations, but is always somehow within walkable distance of the countryside.

Evidence of Exeter's lively 2,000 years of history is not hard to find. Physical relics of the past are everywhere, from a fragment of Roman wall and the underground tunnels to a statue of a soldier or scholar. That's even before we mention the hugely impressive medieval cathedral.

An intrepid time traveller would find plenty of sights to entertain them in Exeter, from a fleet of Tudor sailing ships moving down the canal and William of Orange's men overrunning the city in 1688 to a performance by the Fab Four in 1963. Much

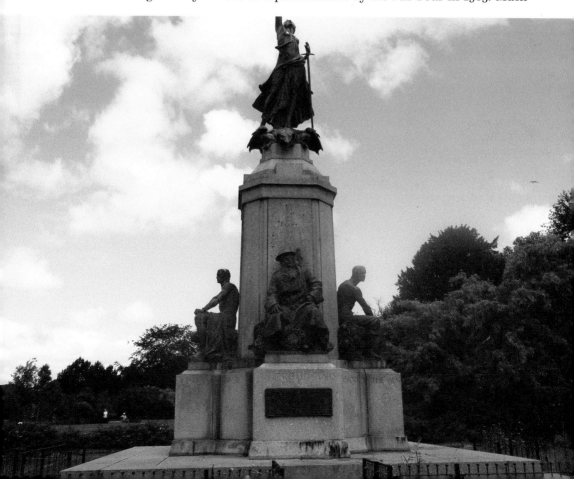

of the city's history has been violent or turbulent. Some local readers may still have personal memories of the horrors of the Exeter Blitz. Further back in the past, the city has been subject to plagues, war, turmoil and sieges. It has suffered harm at the hands of many potential and actual invaders, sometimes from abroad, sometimes from much closer to home.

This is not a comprehensive history of Exeter. Naturally, I've had to make choices about what and what not to include. I obviously couldn't cover everything and as this volume is presented in alphabetical order, I was further constrained by the need to follow the rules of the alphabet. On occasion, I have cheated. Exe Bridges obviously begins with an 'E' not an 'X,' but as there are no historical events I know of featuring either x-rays or xylophones, I hope readers will grant me a little leeway. Hopefully, you will agree, most of the key places, people and events of Exeter's past have been included.

The story of Exeter is an endlessly fascinating and compelling one: 2,000 years of castles, cathedrals and civil war, sieges, students and shopping centres, witches, walls and world wars. Bombs have fallen here. Books have been written. Battles have been fought. Houses have moved. It is a story that still has a long way left to run.

Magdalen Almshouses. Pleasant to look at, they were completed in 1863 using Heavitree stone.

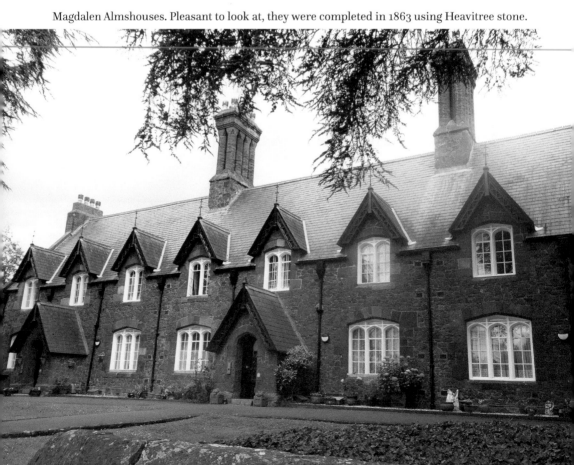

A

Airport

'It is no coincidence that in no known language does the phrase "As pretty as an airport" appear', wrote the Cambridge-born author Douglas Adams. In this he was undoubtedly right, but as airports go, Exeter Airport isn't an especially bad-looking one, perhaps because it is relatively small. Many people, having landed at Exeter, say it feels a bit like they've landed in the middle of a field. This is perhaps unsurprising, because basically they have done.

Out of a current national total of forty, Exeter Airport is the twenty-third largest airport in the UK, with around 900,000 customers and around 40,000 aircraft departures and landings per year (as of the years 2016 and 2017). It first opened in 1937 and the Great Devon Air Race was held at Exeter in July of the same year. Officially, it did not open until 30 July 1938, when the first stage of the terminal was completed.

By that worrying stage in global history, however, it was fast becoming clear that Exeter Airport was soon going to be needed for more than simply staging jolly air shows. In September 1939, the Second World War broke out. All commercial flights in the UK stopped. The airfield was handed over to the Air Ministry and three hard runways and new hangars were constructed as Exeter increasingly assumed a very important role in the war effort. A major user of Exeter was the Gunnery Research Unit, which carried out a large number of important trials during the war. Meanwhile, having officially taken over in June 1940, the RAF transferred control from Flying Training Command to Fighter Command in July. Hawker Hurricanes of No. 213 Squadron arrived from Biggin Hill, with more Hurricanes of No. 87 Squadron following shortly after. These and other fighter elements provided an important aerial defence for the south-west coast, carrying out coastal patrols and encountering enemy aircraft. They were also to be heavily involved in the Battle of Britain.

Various fighter squadrons subsequently stayed at Exeter from 1940 to April 1944. Their airfield survived an extremely large number of Luftwaffe bombing attacks in the springs of 1941 and 1942, but from 1943 more focus was based around offensive fighter missions. A few Fleet Air Arm squadrons also carried out anti-shipping operations from Exeter in 1942 and 1943. Exeter played an important role in the 1944 D-Day landings too.

After the war, the airport remained under combined military and civilian control for many years until Devon County Council gained ownership between 1974 and 2007. More improvements to the runways and infrastructure were made from the 1980s onwards and passenger numbers increased. A £3 million terminal and control tower opened in 1981. In 2007, the airport dealt with a million passengers a year for the first time and remains a major regional employer.

Exeter Airport. (Courtesy of N. Chadwick under Creative Commons 2.0)

B

Barings

In 1995, headlines were generated around the world when the second oldest merchant bank in the world unexpectedly collapsed. The bank's downfall is famously thought to have been solely attributable to the actions of 'rogue trader' Nick Leeson. He was later jailed for his role in the fall of Barings.

The Blessed Sacrament in Heavitree has been so named since 1930. The church was damaged by enemy action in the Second World War.

Exeter has little or no obvious connection to the events that precipitated Barings' downfall, but it does have a clear connection with the bank's beginnings. For the bank's founder, Sir Francis Baring (1740–1810), was born in Exeter.

Nearly 300 years before the age of Nick Leeson, ambitious, young Johann Baring (1698–1747) had moved from his German home in Bremen to take up a position as an apprentice in a wool-exporting business in Exeter in 1717, initially lodging in Palace Gate. He made a success of himself, changed his first name to the more English-sounding 'John', married well and by the 1740s was one of the city's wealthiest citizens. In 1748, his sons inherited a successful manufacturing and export business. With this legacy they were able to start a bank in 1768, which soon became Barings Bank.

Although by now London based, the Barings retained links to Exeter. In 1770, the oldest son, John, returned to Exeter, purchasing the manor of Heavitree, building himself a mansion on this area that includes Mount Radford and the hill above Larkbeare.

Blitz

It was back in the mid-nineteenth century that Karl Ludwig Johannes decided to launch a brand-new series of books. Karl was from Prussia, the large state in what would soon become the brand-new nation of Germany.

Karl's books were to become particularly distinctive in a number of ways. For one thing, they would have striking red covers and gilt lettering. For another, they would become known as 'handbooks' and would be essentially what we now know as travel guides. For another the books would adopt a 'star' rating system, which, although not original, would ultimately become famous. In time, they became the most successful series of travel books to have ever been produced.

Karl, who adjusted his family's surname to 'Baedeker' in the 1850s and died before Germany was even established as a nation state, could not in his wildest and most terrible dreams have foreseen how his books would be used nearly a century later.

The 1937 edition of *Baedeker's Great Britain* awarded three stars to Bath, Bury St Edmunds, Cambridge, Canterbury, Norwich, York and Exeter, indicating that they had been deemed of cultural value. The same volume was reportedly used by the Nazis to plan which cities to bomb as part of one of the most notorious campaigns in the Second World War. The campaign was conceived as revenge for the devastating RAF raid on the undefended German city of Lubeck in March 1942, which had killed over 300 people. Exeter became the first victim of what became known as he Baedeker Blitz.

The Second World War was to prove even bloodier than the first, adding 60 million global dead to the already horrendous total of 40 million notched up during the First World War. From the British perspective, the overall human cost was less terrible in the second conflict, yet the figures came with a nasty sting in the tail. Whereas manned flight was still in its infancy in 1914, by 1939 humanity had mastered the macabre art of mass aerial bombardment. The consequence of this was that while

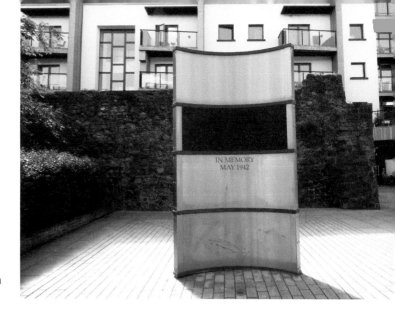

The official memorial to the Exeter Blitz in Roman Walk.

around 1,400 British civilians were killed by air raids (notably zeppelin attacks) in 1914–18, in 1939–45 British civilian deaths totalled over 67,000, nearly fifty times as many as many as in the war against the Kaiser.

Following the attack on Lubeck, a furious Hitler had declared: 'that the air war against England be given a more aggressive stamp. Accordingly, when targets are being selected, preference is to be given to those where attacks are likely to have the greatest possible effect on civilian life. Besides raids on ports and industry, terror attacks of a retaliatory nature are to be carried out on towns other than London.'

The idea was to destroy British cities of great beauty and cultural worth but of no particular strategic value in the hope of depressing British morale. In fact, Exeter did have some strategic value – supplies were frequently transported through the city to both Plymouth and Dartmouth – although this was not why the city was attacked.

Exeter was little affected by small-scale air raids early in the war. In August 1940, the *Express* and *Echo* reported the first bombing in St Thomas: 'Little damage was done to property, and the only casualties were a middle aged man who was able to walk to a first aid post, a canary which died from shock and a few chickens.' There seemed to be a deliberately humorous element to the report, doubtless intended to keep morale levels up, but there was nothing funny about the raids of 1942.

The Exeter Blitz occurred on three separate nights: 23 and 24 April and 3 May 1942. Ironically, this was during a period generally seen as marking an overall lull in German bombing activity over Britain following Hitler's ultimately disastrous invasion of the Soviet Union in July 1941.

On the first night (23/24 April), 200 houses were damaged, and five people were killed when seven bombs fell on St Thomas and Marsh Barton. It was undeniably bad but could have been much worse. Dense cloud coverage prevented many German bombers from hitting their targets. However, the next night, a large number of bombers were dispatched again, and this time, the night was clear. Now, the bombing was substantially worse.

The second raid saw parachute flares dropped to illuminate the proposed targets for the German dive bombers. Large numbers of 1 kg incendiary bombs were dropped

over Pennsylvania and elsewhere. This time, seventy-three died and a further twenty were seriously injured.

Again, much worse was to come. The German Luftwaffe targeted other towns during the next week, but on 4 May, they returned to Exeter. This time, the attack was worse than ever. Twenty German planes flew up the Exe Estuary and destroyed the Fire Barge before dropping incendiary bombs on the city. These ensured the city was soon ablaze as Exeter struggled to survive a growing inferno. Ultimately, fires raged in Newtown, High Street, Sidwell Street, Fore Street and Haven Banks.

The figures make shocking reading. In nineteen raids on Exeter, 265 were killed and 111 seriously injured while 677 were injured to a lesser extent. Many of the dead were buried in a mass grave in Higher Cemetery. Of 20,000 houses in the city, 1,500 were destroyed and 2,700 seriously damaged. In other words, 7.5 per cent of all houses were destroyed, and fifth of houses were either destroyed or seriously damaged.

On 4 May, German radio is said to have reported: 'Exeter was the jewel of the West ... We have destroyed that jewel, and the Luftwaffe will return to finish the job.'

Of course, as we know, German radio was wrong. The Exeter Blitz was probably the most traumatic event in the city's history, however, and has left its mark to this day, but Exeter did recover.

The cathedral did not escape the Exeter Blitz: St James' Chapel was destroyed by a direct hit in 1942.

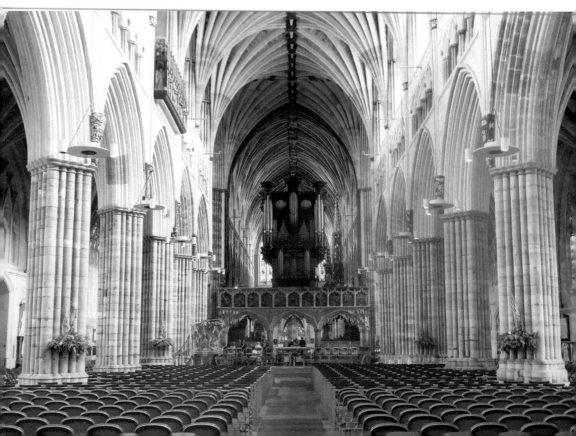

The ruins of the fifteenth-century St Catherine's Almshouses, which were bombed during the Exeter Blitz.

Blue Boy

This is the Blue Boy statue, a single defining feature of the Princesshay shopping area. It is small and has the following inscription underneath:

> THIS STATUE OF A BLUE BOY
> STOOD IN THE COURTYARD OF
> SAINT JOHN'S HOSPITAL SCHOOL
> FOUNDED ON THIS SITE
> AS A BLUECOAT SCHOOL
> BY THE CHAMBER OF EXETER,
> A.D. 1636 IN THE
> DISSOLVED MEDIAEVAL HOSPITAL
> OF SAINT JOHN THE BAPTIST.
> THE SCHOOL CONTINUED UNTIL 1931
> IN THE NEW BUILDINGS ERECTED IN 1859
> WHICH WERE DESTROYED BY
> ENEMY ACTION ON MAY 4TH, 1942

Little needs to be added to this. The statue, which was cast in 1860, indeed serves as a reminder of the existence of the St John's Hospital School near this site, closed in the 1930s and destroyed in the 1940s. The pupils were known as 'blue boys' because of their uniforms. This particular boy remains a striking feature of the Princesshay landscape.

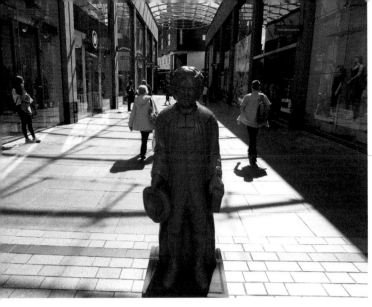

The Blue Boy of Princesshay.

Relief of St Sidwell, on Sidwell Street, St Sidwells. The parish was once mentioned in a column written by Charles Dickens.

Bodley, Sir Thomas

The name 'Bodley' is always more likely to be associated with Oxford than Exeter. Thomas Bodley did, after all, found the famous Bodleian Reference Library at Oxford University, which is the second largest library in Britain (after the British Library) and one of the oldest libraries in Europe.

Thomas Bodley (1544–1613) himself, however, was undeniably a local boy and was born at what is now No. 229 High Street, Exeter, on the corner with Gandy Street. His parents were of local stock as well: his father John Bodley was a merchant from Exeter, and Joan was the daughter of a merchant from Ottery St Mary. Thomas's acquaintance with the city ended early on, when his parents, who were Protestants, took the family out of the country during the brutal Catholic regime of 'Bloody' Mary (Mary I, Henry VIII's oldest daughter) between 1553 and 1558. Thomas was educated

for a while at John Calvin's Academy in Geneva, before starting his Oxford career on his return to England following the succession of Elizabeth in 1558.

Bodley enjoyed a distinguished career as an usher to the Queen and as a Member of Parliament and diplomat, but it is for his role in refounding the famous library that now bears his name for which he will always be best remembered. The library had in fact been started before but had been totally abandoned for decades by the time Bodley started work on it.

On knighting him in 1604 James I of England (James VI of Scotland) remarked that he should be called 'Godly' not 'Bodley'.

Buller, General Redvers

Few statues are more conspicuous in the city than that of General Redvers Buller (1839–1908). The statue of the old soldier on horseback was created by Adrian Jones. It is situated by Bury Meadow, exactly where the roads divide. Hele Road leads down to St David's station while New North Road leads to Crediton. Crediton was in fact Buller's birthplace. Buller is depicted in full dress uniform and greatcoat. As Gilbert and Sullivan might have said of the statue: 'it is the very model of a modern major general.'

Born to a very wealthy and distinguished local family, the positive aspect of Buller's reputation is based almost entirely on the events of one single day. In one day of spectacular heroism performed as a young lieutenant, during the rapid retreat from Inhlobana at the height of the Zulu Wars in 1879, Buller rescued wounded and vulnerable men in three separate incidents while on horseback at the height of the Zulu pursuit. He was awarded the Victoria Cross for his actions.

Above: General Buller's statue.

Right: Was General Buller a hero or a villain?

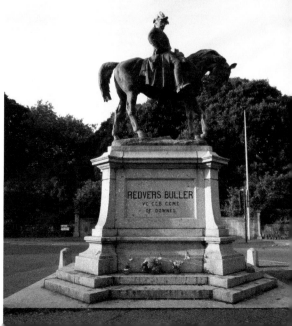

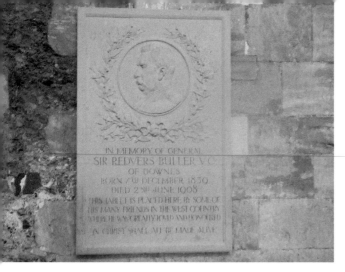

Buller remains a controversial figure.

Buller's later career as a general during the 1899–1902 Boer War is remembered less favourably now. The ageing Buller had only accepted the call to command again reluctantly but ended up being retired on half pay after military confrontations at Coleno and Spion Kop ended badly. Buller spent his last years delivering talks to local schools. In retrospect, it is perhaps unsurprising that some have questioned whether Buller deserves to be immortalised as a statue at all.

At the time, however, many feel he had been unfairly blamed, perhaps being scapegoated for the failures of others. Attitudes to empire and to the upper classes were different in those days. Buller's family were distinguished locally, and his father had been a nineteenth-century MP. The old soldier clearly still had his fans. The statue itself was erected after donations were received from around 50,000 admirers. Unusually, Buller himself was present to attend the ceremony when his own statue was unveiled in 1905 – usually such statues only spring up after the subject's death. Less than a decade later, many of the men and boys present at the unveiling would be marching past his statue on the way to France and Belgium to fight in the First World War. Buller, the man, did not live to see this particular war or this procession, the start of a long journey from which many of the young men in uniforms would not return.

Buller, Georgiana

No statue exists to commemorate the life of the only daughter of the famous soldier Redvers Buller. Many would doubtless argue, however, that she is perhaps as deserving of a statue as her father, if not more so. She was the founder of the first school dedicated to occupational therapy.

Born in Crediton, Georgina (1884–1953) had already been a member of the Red Cross and as Deputy County Director of the Voluntary Aid Organisation for Devon when the First World War broke out on her thirtieth birthday in August 1914. It was to be a fateful time in Georgina's life. The same year saw her suffering a serious spinal injury after a hunting accident. Despite this, her life's work was about to begin.

During the First World War, Georgina established and oversaw the rapid expansion of a hospital in the city, ultimately becoming one of the first female hospital administrators after the War Office took it over, making it Central Military Hospital Exeter in 1915. By the end of the war in 1918, she was responsible for over forty hospitals.

She was appointed Dame Commander of the Order of the British Empire (DBE) in 1920 and also awarded the Royal Red Cross 1st Class (RRC). She had become a noted advocate of disability rights. 'Normality!' she argued, eloquently. 'This is the goal to which every disabled individual, without exception, passionately aspires and which all, in their degrees, can achieve if given the right encouragement and opportunity.'

The record of Buller's achievements in the interwar era is impressive. In 1927 she opened the Princess Elizabeth Orthopaedic Hospital in Exeter. A decade later she followed this by starting what became St Loye's College for Training the Disabled and is now St Loye's Foundation. Furthermore, in 1932 she opened Queen Elizabeth's Foundation for Disabled People in Surrey and also founded the British Council for Rehabilitation.

'In nature there's no blemish but the mind. None can be called deformed but the unkind,' she once said. A tough, very determined character, she died in 1953. She never married.

The Bullers were a prominent Devon family for a long time, as this memorial in the cathedral reminds us.

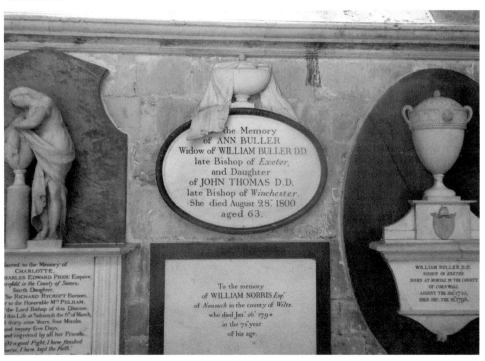

Canal

The district of Countess Wear takes its name from Isabella de Fortibus, the Countess of Devon, who reportedly built the weir to power her mills there in the thirteenth century. However, the story is not quite as simple as that. Whether she herself ordered the construction of the weir is unclear. What is not in doubt is that the weir damaged the local salmon fishing industry as it prevented shipping reaching Exeter, forcing goods to be unloaded at Topsham Quay, within her manor. According to some accounts, Isabella's successor, Hugh Courtenay, deliberately blocked the gap with tree trunks between 1317 and 1327, cutting off Exeter from the sea and allowing Topsham to steal its maritime trade.

The dispute wasn't resolved until Tudor times, when in 1556 Henry Courtenay, one of Hugh's descendants, was executed for treason and – after some further delay – the city of Exeter was finally given permission to demolish the weir. This proved difficult. A 3,000-foot canal was built to bypass it instead.

In the seventeenth century, it was decided to extend the canal from Countess Wear and deepen it. The quay was then extended to its present length. The distinctive Custom

Exeter's Quayside was used as a location for the long-running 1970s TV series *The Onedin Line*.

House was built in 1681, 'One of the handsomest buildings in Exeter,' according to the famous Exeter historian W. G. Hoskins. It was also the first Exeter building to be built in brick. By the start of the Georgian era, the canal had been deepened and extended to Topsham. Ships could now come right up to the city and unload there. Trade flourished with Holland, Spain, Portugal and Italy. It was a good time to be a merchant. It did not last.

The canal was extended further in the 1830s but was quickly superseded by a new invention: the railways. Times had changed forever.

Cathedral

The cathedral has been a feature of the Exeter landscape since the twelfth century. Indeed, a version of it was arguably there even before that. A Saxon minster was already in existence when construction of the Norman Cathedral was started by Bishop William Warelwast in 1114. Warelwurst was the second bishop of Exeter and a nephew of William the Conqueror. In 1133, the canons formally left the old building for the new one. Fire broke out in the 1130s during the civil war between two more of William I's relatives, King Stephen and his cousin Matilda. Today, the north and south towers are all that remains of that early Norman cathedral. These bits were windowless and more castle-like in some ways. The next century would see the cathedral expand still further.

Bishop Walter Bronescombe (who lived from around 1220 until 1280) played a crucial role in the building's development, opting to rebuild the cathedral in a new style with more windows and less heavy walls to support the roof. This made the cathedral brighter and less gloomy. According to some accounts, Bronescombe, who had been enthroned as Bishop of Exeter in 1258, had attended the consecration of Salisbury Cathedral and had been much inspired by what he had seen there. Among other changes implemented

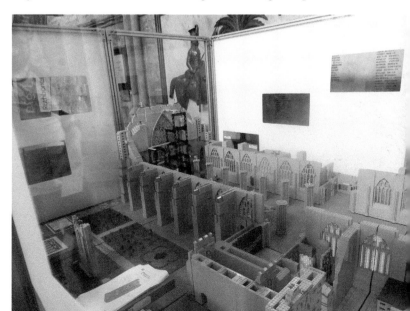

Lego version of Exeter Cathedral.

before his death was the removal of the curved Norman apse at one end and a new Lady Chapel being built behind the high altar. Bronescombe would eventually be buried in the chapel himself, missing the completion of the cathedral by a full century. Much of the funding for the construction of the building in the fourteenth century came from the wealthy Bishop Walter Stapleton, who was also treasurer to the king. Stapleton spent little time in Exeter but gave generously. The cathedral was finally completed in 1382, having been further delayed by an outbreak of plague.

During the Exeter Blitz the cathedral was subject to a direct hit. A 500-pound bomb destroyed the chapel of St James. Witnessing the restoration process in action, a visiting George VI saw the fragments laid out on the floor and called it 'the greatest jigsaw puzzle in the world'. Today, a more modern stained-glass window clearly makes direct reference to the Second World War.

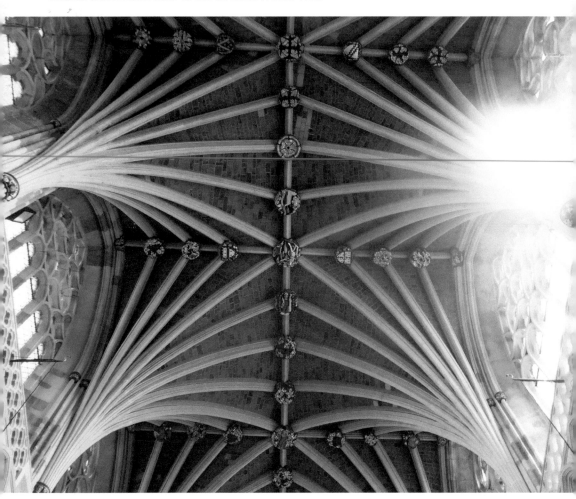

The cathedral has the longest continuous medieval stone vault in the world. The cathedral is also briefly referred to in Bram Stoker's 1897 novel *Dracula*.

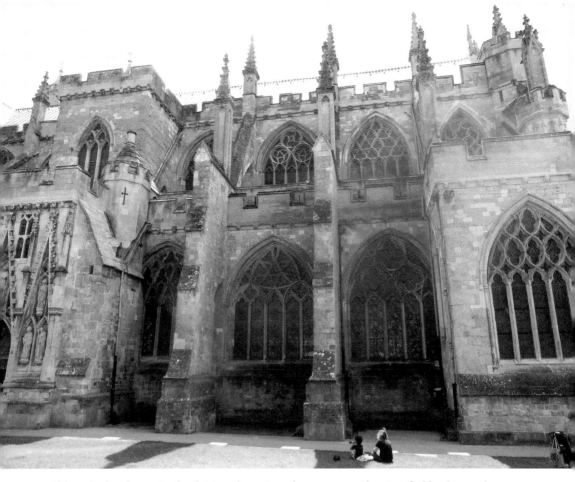

Although placid now, in the thirteenth century the green was the site of a bloody murder.

Exeter Cathedral has a number of outstanding features, which are too numerous to mention in full here. It has the longest vaulted continuous medieval stone roof ever built. The bishop's throne, made of English oak, is 60 feet tall and, amazingly, contains no nails at all. The west screen, the first thing you see as you approach the cathedral from outside, features numerous statues of men – angels, kings, knights and apostles. The work of a talented mason called William Joy, it was meant as a vision of heaven and is believed to have once been in full colour.

The historian W. G. Hoskins wrote in his book, *Devon*, that 'Exeter may well claim to be the loveliest of all English cathedrals.' Few who have seen it would disagree.

Cathedral Green Murder

It was a morning like no other in Exeter history. On Tuesday 9 November 1283, a man dressed in white robes was set upon by a mob within a short distance from the still yet uncompleted Exeter Cathedral.

The attack occurred on what is now Bear Street, where an area of Exeter Cathedral School now stands, but this was no random medieval assault. The assailants knew

exactly what they were doing. Their victim was Walter Lechlade, the precentor of the cathedral, and his attackers were fierce: soon Lechlade was dead.

Trouble had been brewing for some time. There had long been a feud between the city's guilds and the growing cathedral over who held the balance of power in the city. Recently, a new row had erupted between Bishop Peter Quinil and Dean John Pycot. Lechlade, appointed by the bishop in a bid to strengthen his position, ultimately seems to have borne the brunt of popular anger on the part of Pycot's followers, although, in truth, exactly what happened is unclear.

What is known is that twenty-one people including John Pycot and the city's mayor, Alured de Porta, were ultimately charged with involvement in the conspiracy. Edward I himself came to oversee the trial, which took place in the Great Hall of Exeter Castle during December 1285. Five men were executed including the mayor. Pycot

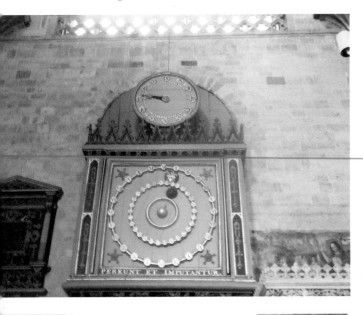

The cathedral's famous Astronomical Clock.

The cathedral remains the city's biggest tourist attraction.

One of Britain's finest cathedrals.

himself, though thought to be guilty, took full advantage of his right to be punished by the church authorities rather than the secular ones. The church authorities proved incredibly lenient: ultimately, if Pycot did have any role in planning the murder on the cathedral green on that fateful autumn day in 1283, he largely got away with it.

Cinemas

Exeter has three cinemas. The Exeter Picturehouse, part of the City Screen chain, opened with a screening of the grim Thomas Hardy adaptation *Jude*, which starred rising stars Christopher Eccleston and Kate Winslet in October 1996. The screening was attended by the director of the film, Michael Winterbottom. Although far from exclusively arthouse, the cinema specialises in generally less mainstream films. It also has a very pleasant bar area, which plays host to a fiendishly difficult film quiz once every fortnight.

Exeter's Vue cinema opened in December 2006 and is a general multiplex.

The Odeon is currently Exeter's oldest existing cinema. Opening in 1937, it was initially a large auditorium capable of seating over 1,900 people. Early visitors were treated to footage of the coronation of George VI, brought to the city courtesy of a plane arriving from the capital at the city's new airport.

Not everyone was a fan of the Odeon. In 1946, Thomas Sharp described it as 'a great hump-backed mass on the summit of the Sidwell Street ridge – a shapeless lump of a building which rides the city like a totalitarian mammonmite cathedral'. However, the cinema – which is now much smaller than it once was, with four screens – has been popular enough to survive eighty years and a world war. Indeed, there is still visible evidence of shrapnel damage on the cinema's steps after a bomb exploded on the other side of Sidwell Street in 1942.

Earlier cinemas in Exeter's history, all now long since closed, included the Empire Electric Theatre, City Palace, The Queens Hall (later The Palladium), The King's Hall and The Franklin.

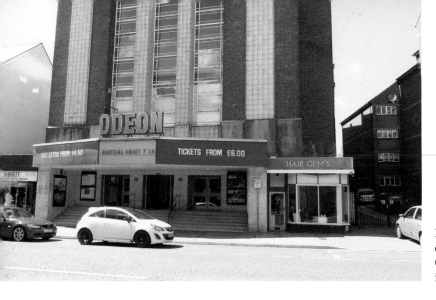

Exeter's oldest cinema, the Odeon, opened in 1937.

The ABC disappeared in 1987 after nearly fifty years of business, screening the popular Tom Cruise film *Top Gun* and the Julie Walters comedy *Personal Services*, shortly before it closed forever. Today, a bookshop is on the same site. The Beatles once performed a show in the building in November 1963.

Civil War

Exeter's motto 'semper fidelis', meaning 'always faithful' is believed to have been conferred upon the city by Elizabeth I. 'Good Queen Bess' was pleased with the city and awarded the title in acknowledgment of the city's gallant contribution towards defending England at the time of the 1588 Spanish Armada.

The queen died in 1603. Had she lived, she would doubtless have been horrified to learn that her kingdom would be torn asunder by the Civil War within forty years of her demise. She would also doubtless have been surprised to learn that 'always faithful' Exeter would succumb to a conflict of loyalties in the subsequent conflict, backing both the Royalist and Parliamentary forces at different times.

The Civil War (1642–51) is thought to have been the bloodiest ever war in British history in terms of the number of deaths relative to population size. Around 4 per cent of the population of England and Wales were probably killed and perhaps far more than that in Scotland and Ireland. It was essentially a conflict between the Royalist forces of Charles I (1625–49) and the Parliamentary powers who came to be led by Huntington-born parliamentarian Oliver Cromwell. Charles was ultimately defeated and beheaded in 1649. After a generally unhappy decade of puritanical republican rule, the monarchy was restored in 1660, when Charles I's exiled son was crowned Charles II. Generally, however, the outcome of the war continued the gradual movement of political power away from the monarchy and towards Parliament, which is why the monarch exercises little real practical influence today.

Exeter played a central role in the conflict. The years were tough ones for the city, with the city being besieged three times.

Right: A familiar name, the pub's title refers to a legendary incident in which the future Charles II evaded capture during the Civil War by hiding up an oak tree.

Below: Custom House, reportedly the first building made from brick in the city.

Initially, Exeter had attempted to adopt a neutral position, but ultimately came out in favour of Parliament. A number of leading Royalist figures withdrew from public life but Exeter's republican leaders could not afford to rest on their laurels. Exeter came under sustained and repeated assaults from, at different times, Sir Ralph Hopton's army of Cornishmen, another army led by Sir John Berkley and a naval fleet led by the Earl of Warwick, the last of which proceeded to bombard Topsham. Later, a bitterly fought battle at Hayes Barton and the intervention of Prince Maurice's forces put Exeter's rebel status under still more pressure.

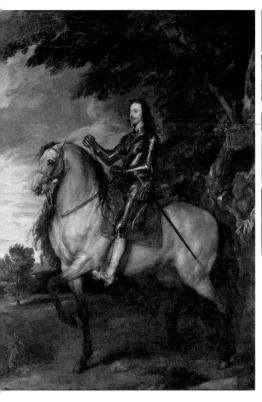

Above: In addition to the university, Exeter has a college that was established in 1970. It currently provides education for around 10,000 to 12,000 students.

Left: Charles in charge? Not for long. The Stuart king fought and ultimately lost the English Civil War.

By 1643, with the population weakened by an outbreak of typhus, sieges and a series of battles, the city finally succumbed reluctantly to Royalist forces. This period saw the birth of Princess Henrietta in the city, the daughter of Charles I. The king briefly visited and saw her for the first and, as it turns out, only time. This era also saw unease as the Royalists attempted to consolidate their fragile grip on power by forcing citizens to swear an oath of allegiance to the king. Hundreds of Exonians were driven into exile after they refused to sign.

Generally speaking, however, despite a further siege and renewed efforts by Parliamentary forces to recapture the city, it ultimately took the overall defeat and surrender of the Royalist side to release the city from their grip.

In short, for Exeter particularly, the English Civil War was a very challenging period indeed.

Cooper, Tommy

'Just like that!' The world of comedy will never forget Tommy Cooper (1921–84). Known throughout the globe for his distinctive fez, unusual appearance, gruff voice and silly laugh, a key element of Tommy's act was his propensity for attempting magic tricks that always went wrong. In fact, just as his fellow comic Les Dawson – who was famed for his terrible piano playing – was in fact an accomplished musician, Tommy

was, in real life, a genuinely very adept and talented magician. He became one of the most instantly recognisable figures in the world.

In fact, it was a childhood period spent living in Exeter that was to prove crucial in developing this particular skill. Cooper was born in Caerphilly, Wales, but moved to Exeter, close to his mother's birthplace of Crediton when he was three. It was here, while living at Ford's Road off Willey's Avenue at the back of Haven Banks, that he was given his first ever magic set as a present from an aunt. He was enchanted by it.

Tommy attended Mount Radford School, but the family abruptly moved to Southampton, away from Devon forever, when Tommy was nine. Throughout his hugely successful career, Tommy was often a difficult character and had many ups and downs. 'Do you like football, Ma'am?', he once asked a rather surprised queen, after formally meeting her in a line-up after a Royal Variety Performance. When she replied no, Tommy asked, 'can I have your Cup Final tickets, then?'

He spent his career in showbiz, tragically dying soon after collapsing during a live TV performance in 1984. In many ways his destiny had been sealed forever on the day he received that magic set in Exeter.

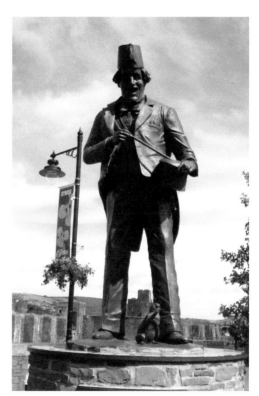

Memorial to Tommy Cooper. (Courtesy of Eddie Reed under Creative Commons 2.0)

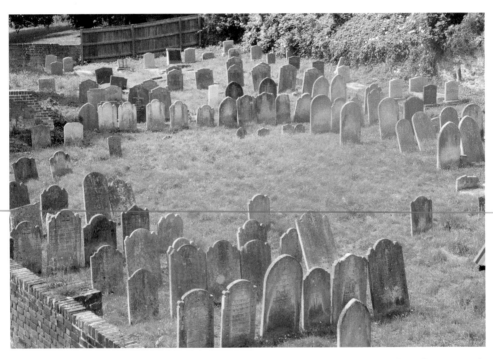

The Dissenters' Graveyard includes the graves of many who in the eighteenth and nineteenth centuries opted to pursue a different religious course from the Church of England.

Districts

Exeter is made up of other different areas or districts. Some of the key ones are detailed here.

Once a village, Alphington is now the third largest ward in Exeter and is noted for its fifteenth-century St Michael and All Angels Church. Charles Dickens' parents lived here for a while from 1839.

Close to St David's station, Exwick was mentioned in William the Conqueror's Domesday Book.

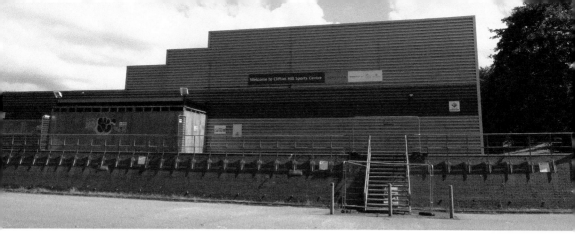

Above: Clifton Hill Sports Centre in Newtown. Opened in 1984, it was designed by Nicholas Grimshaw, the man who later created the Eden Project. It is now closed.

Right: *The Heavitree Arch*, a controversial piece of artwork from 2008, situated in Gordon Place.

Heavitree is named after a tree – 'Heda's Tree' or 'Head of a tree'. The first mention of Heavitree dates back to 1086, although there was probably a Christian church on the site as early as the seventh century. The village was assimilated into Exeter in 1913.

Marsh Barton was once a medieval village, but is now Exeter's largest industrial estate, notable for the huge number of cars. There are currently plans to build another railway station there.

Newtown was for a long time seen as an area for the poor. For a long time it was a rural area and home to at least two workhouses. Newtown was badly affected by both cholera outbreaks in the nineteenth century and by German bombers during the Second World War.

Pennsylvania, not to be confused with the US state of Pennsylvania, is a suburb to the north of the city. It is close to the university and so is often favoured by students looking for accommodation. J. K. Rowling stayed here during her time as a student in the 1980s.

Pinhoe was incorporated into Exeter only in 1966 but has a long history before that. 'Pinnoch' is mentioned in the Domesday Book and before even that, the area was subject to a major Viking attack in the early eleventh century. There is a small unmanned railway station.

St Thomas was incorporated into Exeter in 1900. It is served by the St Thomas railway station, which opened in 1846.

The Georgian era (1714–1830) was an interesting time incorporating the Industrial Revolution, the loss of the American colonies, the birth of the modern novel and drama of the Napoleonic wars. It was a great period for Exeter in particular.

The typically Georgian buildings of Southernhay, home to many offices and businesses, were actually built towards the end of this period between 1824 and 1825 but perfectly exemplify the architecture of the era. Sadly, even as these buildings were built, Exeter had ceased to be an important commercial and industrial city, most of its trade having been killed off by the Napoleonic wars. Southernhay remains an attractive part of the city, however, boasting an abundance of greenery.

Sowton is a small industrial estate, now notable locally for its Park and Ride bus service and the small Digby and Sowton railway station nearby.

Topsham was designated the status of a town in a royal charter of 1300. It remains a town even though it is within Exeter. It is served by the Topsham railway station, which opened in 1861.

Between 1956 and 1988, Whipton played host to the Devon County Show before the location moved to Westpoint Arena.

Wonford covers parts of St Loyes and Heavitree. The main site of the Royal Devon and Exeter Hospital is based there.

Southernhay, Exeter's business centre.

Pinhoe Road Baptist Church.

E

Exeter Castle

Legend has it that in 1066, William of Normandy defeated the Saxon King Harold at the Battle of Hastings and then took over England in what has become known as the Norman Conquest. This legend is, in fact, basically true. That said, the invasion did not go quite as smoothly as is often thought.

One notable bastion of resistance was Exeter (then known as Escanceaster by the Saxons), where Gytha, the mother of the late King Harold, was rumoured to be located

He stooped to conquer: William I had the castle built after struggling to win control over Exeter.

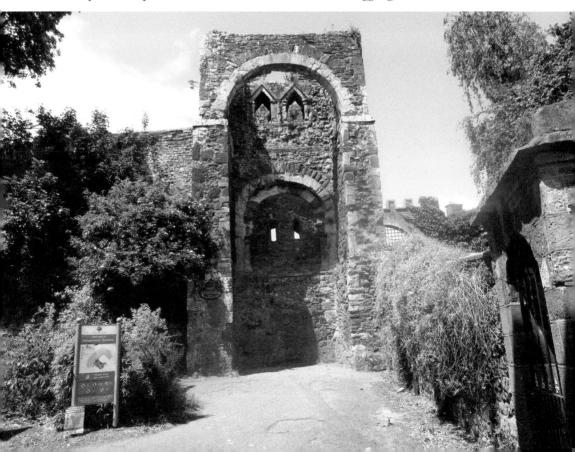

and which rose in rebellion against William in 1068. William was forced to come to Devon himself to sort the mess out. A violent and bloody siege ensued. Indeed, the result was far from an outright victory for the Normans. England did not come under full Norman control was 1072. Exeter itself only fell on condition, William did not attempt to punish its inhabitants either through violence or extra taxes. Gytha seems to have escaped in the meantime (assuming she was ever there in the first place).

A lasting consequence of all this upheaval was the construction of a castle on nearby Red Hill to keep a watchful eye on the city's potentially volatile populace. The hill was red because of the colour of the volcanic soil and the castle has become known as Rougemont, or just Exeter Castle. It has played a significant role in both local and English history, notably in the twelfth century civil war between King Stephen and Matilda and the more famous seventeenth-century one between Charles I and Cromwell.

Today, Exeter Castle remains the earliest Norman castle building still in existence, predating the more famous White Tower at the Tower of London by a good decade. Although little more than the castle walls remain, these do include the original Norman gatehouse, widely considered to be one of the best examples of early Norman architecture still to be seen in Britain. Ironically, a flaw in the design of the gatehouse essentially made them useless from the outset. It is this very uselessness that has ensured their survival to this day.

Fire: 1887 Theatre Royal Fire

There have been many terrible nights in Exeter history, but few have been worse than that of 5 September 1887. For on that night 186 people were killed when the Theatre Royal Exeter was destroyed by fire. It was the worst theatre fire to have ever occurred in British history. Indeed, it remains the largest loss of life in any property fire in the country to date.

The theatre was located on the junction of Longbrook Street and New North Road. The theatre was still new: it had opened only one year before, ironically replacing another theatre that had also burnt down. This time it had been the opening night of *Romany Rye*, a melodrama by the actor turned playwright Wilson Barrett. Although neither the play nor Barrett himself are much remembered now, on the night 800 people were in attendance. At some point during the fourth act naked gas jets used as lighting set the curtains alight with devastating consequences. Disaster ensued when the blazing curtains collapsed and burning bits of scenery started falling everywhere.

The building's architectural design didn't help. In the light of the tragedy, an inquiry was held, and the role played by the leading Victorian architect Charles Phipps, who had designed the building, was placed under intense scrutiny. Most of those who died turned out to have been sitting in the upper gallery, which had only one exit. Worse still, there was a ticket office halfway down blocking the potential escape route. Some, in desperation, reached the roof over New North Road but could find no way down from there.

A report published the following day was suitably grim: 'Within three minutes the theatre was a roaring furnace,' it read. 'Flames shot up through the roof over the stage and dense smoke poured forth from every window ... Women threw themselves into the streets from side balconies, quite a distance of 40 feet, and the flat lead roof over the portico was crowded with human beings crying for help. Meanwhile the fire had swept with amazing rapidity from the stage, and tongues of flame licked and scorched those on the balconies ... Soon after the outbreak the City Fire Brigade were on the spot, but the water they poured on the fire was absolutely without effect ... The shrieks, as described by one or two who did get outside, were heartrending.'

The flames were visible as far away as Topsham. The poet William McGonagall – now viewed as one of the worst poets there has ever been – composed his own

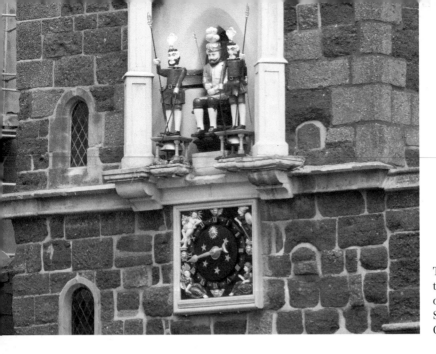

The Matthew the Miller clock on the tower of St Mary Steps Church.

reflections on the tragedy for public consumption. In a more welcome tribute, Queen Victoria, then in her golden jubilee year, sent her personal condolences.

In the grim aftermath, victims were interred in a mass grave in Higher Cemetery in Heavitree. A memorial sculpture by Henry Hems was installed. A national appeal for donations for the victims' families raised £20,763. A new theatre was completed in 1889, which opened with a performance of Gilbert and Sullivan's *Yeoman of the Guard*.

Theatre safety rules were also tightened up as a consequence. The new theatre was the first to use the now legally required fireproof curtains, which the old theatre did actually have but had not used. A generator also supplied the new theatre with electricity, thus reducing the need for potentially hazardous candles or gas.

Fire: 2016 Royal Clarence Hotel Fire

In 1768, the new Assembly Rooms were built by William Mackworth Praed. The building was to become the focus of a famous 'first': it was the first hostelry to call itself a 'hotel' in England. There is evidence the term was used as early as 1770. In 1827, the Duchess of Clarence, the wife of the future William IV, stayed there. It was known as the Royal Clarence Hotel forever after and enjoyed a rich and distinguished history. Many big names stayed there over the years and it was owned by local chef Michael Caines between the years 2000 and 2015. The building was a prominent local landmark and a distinguishing feature of Cathedral Yard.

Sadly, in the early hours of 28 October 2016, the hotel was devastated by a fire that had started in the next building. Thankfully, all of the guests were evacuated and there were no casualties. Despite this, the news undeniably shocked and upset many. At the time of writing, restoration works are in full flow. It is hoped this memorable, historical and distinctive local feature will reopen again soon.

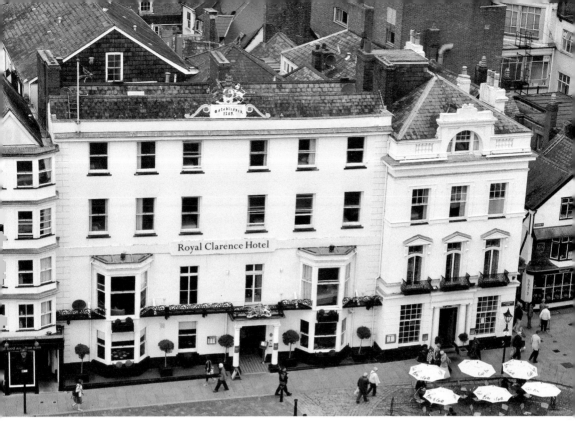

The hotel in its heyday.

The Royal Clarence Hotel as it is at the time of writing.

Government

As it happens, Exeter was only the third city in England to get its own mayor. The first two were London and then Winchester. The mayor was almost certainly a man called Martin Prudom and the honour was bestowed upon the city by the otherwise luckless (and hopeless) King John in 1205. In 1283, Alured de Porta earned a less enviable distinction when he became the only Exeter mayor to be sentenced to death. This was for his alleged role in the cathedral green murder discussed earlier. Much later, Exeter was granted a Lord Mayor in 2002, during the golden jubilee of Elizabeth II.

Exeter's recent parliamentary history is worth exploring too. With only three exceptions, Exeter returned Conservative or Unionist members to parliament in every election of the twentieth century.

The first, St George Kekewich, was elected by a margin of just 100 votes in the great Liberal landslide of 1906. Kekewich was related to Colonel R. S. Kekevich, a hero of the recent Second Boer War. It is generally felt many voted for the Liberal candidate only because they had mistaken him for his more esteemed namesake. Kekevich lost his seat to Conservative Sir Henry Duke in 1910. Duke himself lost to

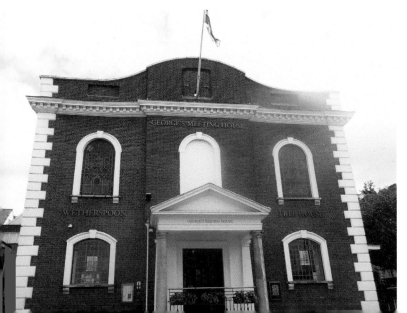

George's Meeting House, once an eighteenth-century Unitarian Chapel, has been a pub since 2005.

Exeter is full of interesting architecture.

Liberal Richard Harold St Maur in the second general election of that year by just four votes. Except he didn't. Duke challenged the result and after a judicial enquiry was declared the winner by just one vote. The result was critical: nationwide Herbert Asquith's Liberals won just one seat more than Arthur Balfour's Conservatives. This was the government that was to lead Britain into the First World War in 1914.

In the 1966 general election, the city generated a small political earthquake by electing Gwyneth Dunwoody. Dunwoody was not only the city's first ever Labour MP, but the first woman to hold the seat. Only 4 per cent of all MPs in parliament were female at this time, among them Betty Boothroyd, Barbara Castle, Shirley Williams and Margaret Thatcher. Dunwoody lost Exeter in the following election in June 1970 but came back to hold the constituency of Crewe and Nantwich between 1974 and her death in 2008. At the time of her death, Gwyneth Dunwoody was the longest serving woman Labour MP there had ever been.

The man who beat Dunwoody in Exeter, Conservative Sir John Hannam, held Exeter for longer than any other MP for the city from 1970 until his retirement in 1997. The battle to succeed him proved unexpectedly fierce. Labour had selected thirty-six-year-old Ben Bradshaw as their candidate, a popular former BBC, *Express* and *Echo* journalist described by the *Independent* newspaper as a 'Hugh Grant lookalike'.

Above left: Ben Bradshaw, Labour MP for Exeter since 1997.

Above right: United Reform Church, Heavitree.

In contrast, the Tories had picked city GP Adrian Rogers as their choice to succeed Hannam. It was a decision that seems to have totally backfired.

As the head of an evangelical group called the Conservative Family Institute, Rogers immediately made a major issue of his opponent's homosexuality. Although openly gay MPs were a rarity at this time (Stephen Twigg who famously defeated leading Tory Michael Portillo in the same election is another example), these fierce attacks proved the source of great controversy.

The result was a resounding victory for Labour and Bradshaw. The swing to Labour in Exeter was far greater than average in Exeter than elsewhere, even in 1997, the best ever general election for that party. As of 2019, Ben Bradshaw has been re-elected five times. He was one of the first ever MPs to formally take part in a civil partnership ceremony in 2006. A former Culture Secretary under Gordon Brown, Bradshaw stood unsuccessfully for the position of Deputy Labour leader in 2015. A passionate pro-European, he has been critical of Jeremy Corbyn's leadership.

Exeter voted to remain in the EU by a margin of 55 per cent to 45 per cent in the controversial 2016 'Brexit' referendum.

H

Henrietta of England

Henrietta Anne Stuart (1644–70) has a truly unique claim to fame: she is the only member of the royal family to have been born in Exeter. Despite leaving the city at a young age, she retained a strong connection to the city throughout her short life. Her portrait hangs in the Exeter Guildhall to this day, having been awarded to the city by her brother, Charles II, after her death.

Henrietta was born into a time of chaos with England torn asunder by the civil war being waged by her own father, Charles I, against the Parliamentary forces of Oliver Cromwell. With the situation desperate, the heavily pregnant Queen Henrietta Maria left her husband to give birth in Bedford House, in the city, a city which had only recently been in enemy hands.

Fearing it might soon be again as the city became imperilled by the forces of the Earl of Essex, the queen fled for Cornwall and ultimately France, leaving her infant daughter in the care of her trusted governess, Lady Dalkeith. Charles I in fact managed to defeat Essex, stopping to see his newborn ninth child on the way. He would never see her again. The young princess was christened at Exeter Cathedral, but eventually followed her mother to France, effectively being spirited out of the country by her faithful governess.

The young princess thus spent her formative years in exile, as England succumbed to Puritan rule following her father's defeat and subsequent beheading in 1649. In 1660, however, fortune seemed to smile on the House of Stuart once again as England threw off the yoke of parliamentary rule and monarchy, in the guise of Henrietta's older brother, Charles II, was restored to the throne. Henrietta suddenly found herself highly eligible wife material and soon married Phillipe, the Duke of Orleans. This turned out to be a big mistake, however, probably a fatal one.

The duke already had something of a scandalous reputation but despite this the marriage seems to have been initially happy and they had two children. Ultimately, however, Henrietta's husband proved a cad, cheating on her and then seeking to promote his mistresses at court.

Henrietta was no pushover, however. Clever, astute and assertive, she fought vigorously to retain her status. A cultured woman, she had a keen interest in gardening and enjoyed a correspondence with the great French writer Moliere. She was also probably having affairs herself.

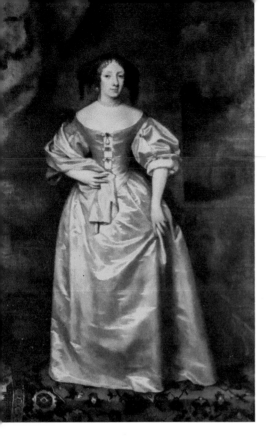

Henrietta, Exeter's only royal.

At the same time, life was tough. She lost a young son in 1666 and gave birth to a stillborn daughter around the same time. Her own mother died in 1669 and it is now thought Henrietta may have been suffering from anorexia.

By 1670 she was involved in high-level covert diplomacy, engineering a secret pact (the Secret Treaty of London) to ensure an alliance between England and France, who would then wage war with England's previous ally, the Netherlands. The secret treaty was well named: it was so secret that it was not made public until well over 150 years later.

Ultimately, these grand designs came to nought, but Henrietta never knew; she had died, aged just twenty-six. The official cause of death was given as peritonitis but many including the dying Henrietta herself suspected poisoning. By strange coincidence, her daughter would suffer a similar fate, also at the age of twenty-six, years later. Then, once again, poisoning was widely suspected.

So ended, the life of Henrietta of England, daughter of one king (Charles I), sister to two more (Charles II and James II) and aunt to the future Queen Anne and ultimately the city of Exeter's only royal daughter.

Hilliard, Nicholas

The name Nicholas Hilliard will always be synonymous with miniature portraits.

For all his talents, Hilliard's life (1547–1619) was not untroubled. He was beset by money worries until the very end and his early childhood was blighted by religious

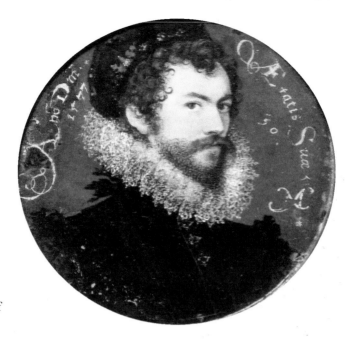

Nicholas Hilliard, master of
the miniature.

upheaval. Born to a goldsmith in Exeter, Hilliard remained attached to the city in adulthood, later inheriting property from his father in the city. The Protestant Hilliards nevertheless fled to France during the tyranny of the fiercely Catholic Queen 'Bloody' Mary I (1553–58) during Nicholas's childhood, only returning when Mary's half-sister Elizabeth succeeded her in 1558. Unsettling as this was, these formative years abroad were probably crucial in making Nicholas Hilliard the great artist he subsequently became.

Very talented and prolific in his day, Hilliard's often oval-shaped portraits, frequently of members of the courts of Elizabeth I and James I and including both these monarchs as well as James's mother, Mary, Queen of Scots, have come to define the late sixteenth and early seventeenth century in the same way that the writings of William Shakespeare are so strongly associated with the same period.

Hooker, John

Not to be confused with his nephew, Richard, John Hooker (c. 1527–1601) was another highly accomplished personality of the Elizabethan era.

Born to a privileged background and despite the death of his father from plague during his childhood, John was successful in a number of fields. A writer and historian, he wrote a vivid eyewitness account of the 1549 Prayer Book Rebellion, which he experienced first-hand. He later wrote a history of all the bishops of Exeter and a biography of his friend, the adventurer, Sir Peter Carew, among other things.

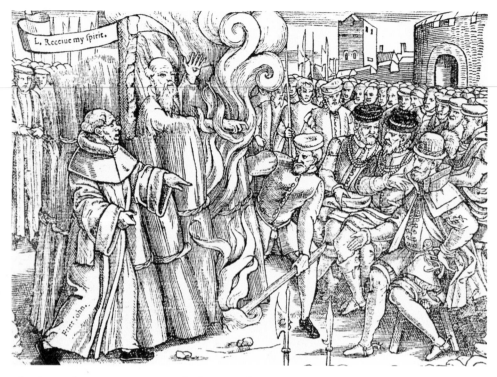

L. Receiue my spirit.

Frier Iohn.

The sixteenth century was a period of unprecedented religious turmoil.

He also devoted himself to public service in Exeter where he served twice as a Member of Parliament, once as city chamberlain and once as coroner. Outside Exeter, his work with Carew also saw him become heavily involved in Irish affairs.

Hooker, Richard

Visitors to Cathedral Green on any fine day are sure to see many people sitting on the grass, talking, reading, eating or looking at their mobile phones. One figure, in particular, can be relied upon to always be there, rain or shine, his attention on his book apparently undeterred by changes in weather, the periodic absence of sunlight or the occasional presence of a seagull on his head.

He is, of course, a statue representing the great Tudor scholar and theologian Richard Hooker (*c.* 1554–1600). The nephew of John Hooker (see above), Richard was born in Heavitree but grew up to become Master of the Temple Church in London and author of *The Laws of Ecclesiastical Polity*, which he began in 1597 but never finished. A great thinker, his statue is probably only seriously rivalled by General Buller's among the most distinctive statues in Exeter.

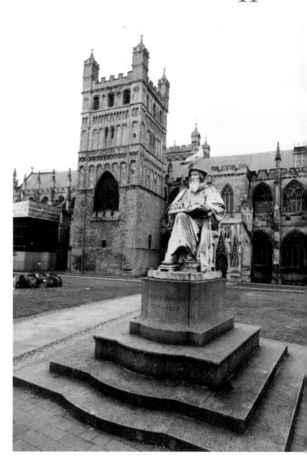

The statue of Tudor scholar Richard Hooker. Sometimes known as 'judicious Hooker', the statue was moved 5 metres in 2010.

Hospiscare

On a snowy day in January 1982, a crowd gathered to hear a speech delivered by Dr John Searle at Exeter's Guildhall. The speech was about an important subject: how society treats those nearing the end of their lives. It was a cold day, but his speech received an enthusiastic response. Dame Cicely Saunders had already founded the hospice movement. The meeting at the Exeter Guildhall led directly to the creation of Hospiscare, one of the most respected local charities in Exeter today.

Initially, the service was focused around a number of nurses who travelled to tend to those in need in their homes. Since 1992, however, Hospiscare has centred around a building on the East Wonford site. The building was renamed Searle House in honour of its founder in 2015. Today, Hospiscare remains a vital source of end of life care for many in Exeter, mid and east Devon and has a dedicated team of devoted employees and volunteers.

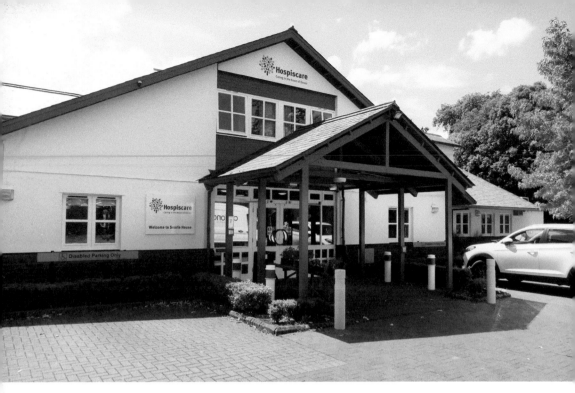

Hospiscare, a vital source of care for many since 1982.

Housing

In November 1918, as Britain emerged from the fog of the First World War, Prime Minister David Lloyd George memorably pledged to build 'a land fit for heroes to live in'. A key element of this was the need to improve the quality of housing. The persistence of slums was a concern throughout Britain. Exeter was no exception.

'To understand what these slums are like', reported the *Devon and Exeter Gazette* in December 1926, 'it was not sufficient to walk through the streets of the poorer quarters of the city-one must penetrate into the courts and alleys with which the city abounds; one must enter into the miserable hovels to realise the unsanitary, unwholesome, airless, sunless conditions under which so many families are living in Exeter'. The vast majority of these people were hard-working citizens living in squalor not from choice but from necessity.

In 1926, an India-born city GP called Charles Newton Lovely (1864–1947) had grown increasingly disgusted with the poor housing conditions he encountered in the course of his work. He established a company called the Exeter Workmen's Dwellings Company with a number of sympathetic fellow citizens. Their aim was to provide good quality, affordable housing.

By the outbreak of the Second World War a total of 550 homes had been built, including houses and flats at Wykes Road, Barley Mount and Foxhayes Road.

During the Second World War many slums were destroyed in the subsequent bombing as were the company's headquarters in Bedford Circus, forcing them

Right: Foxhayes. (Reproduced with the permission of Cornerstone Housing)

Below: Mount Dinham Almshouses. (Reproduced with the permission of Cornerstone Housing)

to relocate to Southernhay East. In 1954, the company became the Exeter Housing Society and was granted charitable status.

In 2008, the company changed its name to Cornerstone and since then has seen its work expand substantially beyond Exeter, as well as within. In 2012, the company took on forty-four almshouses at Mount Dinham and a major refurbishment programme is currently underway. Cornerstone is still one of the biggest providers of social housing in Exeter today.

Above: Peel Row homes converted from the old police station. (Reproduced with the permission of Cornerstone Housing)

Left: Slum clearance was a major concern during the interwar period. (Reproduced with the permission of Cornerstone Housing)

The Exeter Workmen's Dwellings Co. Ltd.

CLEARING AWAY THE SLUMS OF EXETER.

Block of the Company's Houses in Beacon Avenue, Pinhoe Road.

What it has done in 1927-28-29 and what it is endeavouring to do in 1930-31.

Wm. Pollard & Co. Ltd., Exeter. 37254

It is, however, just one example of the work geared towards improving the quality of housing in Exeter. Exeter's first housing association, the City of Exeter Improved Industrial Dwellings Company, began in 1873, building properties on Blackboy Road and the Follett Building in Mermaid Yard off Market Street, both of which were eventually transferred to Cornerstone in the 1960s.

House That Moved

Moving house is never easy, but in 1961 No. 16 Edmund Street – also known as Merchant's House on the corner near Frog Street – entered the annals of city legend as city planners found a novel way to save the Grade II listed fifteenth-century building from demolition. With some difficulty and at some expense, the house itself was physically moved 90 feet up a hill to a new spot opposite St Mary's Church.

The house is famous within Exeter now and is always talked of fondly. However, the project must have generated a few headaches at the time as city planners, keen to build an essential bypass for traffic flowing out of Exe Bridges, worked at a solution to a scheme that, logically, could only end in the demolition of one of the city's oldest buildings. This was at a time when many city councils, particularly Exeter's, were not always overly concerned with protecting the architectural legacy of the past.

However, to their credit, the house was moved. Amid much media interest, the medieval construction was jacked onto rails and moved over a four-day period. It is still there today. Thus, a traveller from the Exeter of the 1430s would doubtless find a familiar sight (although not an entirely familiar site) among the many other bewildering changes that have occurred in the city since his own time. The Merchant's House is much the same as it was then, just not in quite the same place and possibly with some cars parked near it.

The House That Moved. Built in 1430, moved in 1961 and largely stationary ever since.

Isca Dumnoniorum (Roman Exeter)

What have the Romans ever done for us? Well, quite a lot in Exeter's case, as it happens. The words 'Isca' and sometimes the less easy to pronounce 'Isca Dumnoniorum' are to be found all across Exeter. They represent just some of the examples of the legacy of the Roman Empire to be found in the city.

The story of what would eventually become Exeter – it was then known as Caerwysc, also not an easy word to pronounce, meaning simply 'the fortified town on the Exe' – doesn't, in fact, seem to long predate the Romans. The very first people in the area seem to have settled between what is now Fore Street and Bartholomew Street. At least as early as 200 BC, Celtic fishermen, farmers and the like seem to have been at work there.

In what would become a familiar pattern throughout history, these people did not succumb easily to the rule of the Roman invaders. Rather like the village of indomitable Gauls in the *Asterix* books, these early Exonians, who belonged to a disparate collection of tribes known as the Dumnonii, proved resistant. They initially prompted the future Roman emperor Vespasian to besiege the town, but ultimately

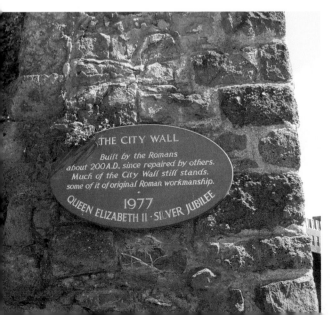

A fragment of city wall.

failing to break the inhabitants down. Later, one of the first ever Roman forts was built to keep an eye on the restless tribal population.

Another legacy left by the Romans lies in the city walls. Although it is true that most of the actual Roman walls no longer exist, it's significant that the current city walls run along very similar lines. Indeed, some original Roman walls do survive, notably the foundations that surround the edge of the hill under the castle in Northernhay Gardens. The ultra-straight Magdalen Road and Topsham Road also provide a lasting impression of Roman influence in Exeter.

However, in the fifth century AD, the Goths attacked Rome and the empire began to disintegrate. The Roman era had come to an end.

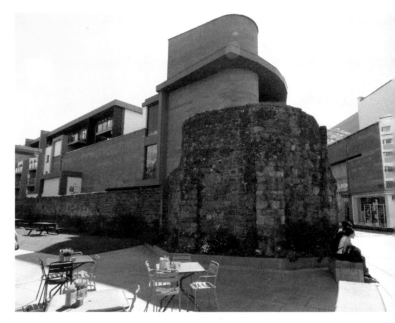

Evidence of Exeter's Roman heritage is clearly visible throughout the city.

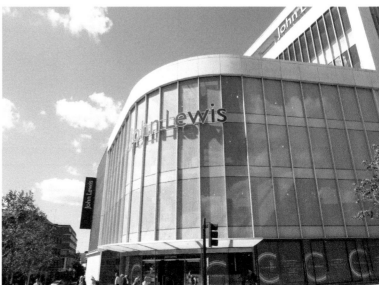

The John Lewis building.

(St) James Park

Once an area used for fattening pigs, St James Park is a football stadium and is the home of Exeter City Football Club, otherwise known as 'the Grecians'. The stadium was built in 1904 and has a capacity in excess of 8,000.

It is next to St James railway station. Previously known as Lion's Holt, the station changed its name to that of the stadium in 1946. The last century has seen the team enjoy many ups and downs. Celebrity fans have included Noel Edmonds, Exeter-born musician Chris Martin and comedy star Adrian Edmondson.

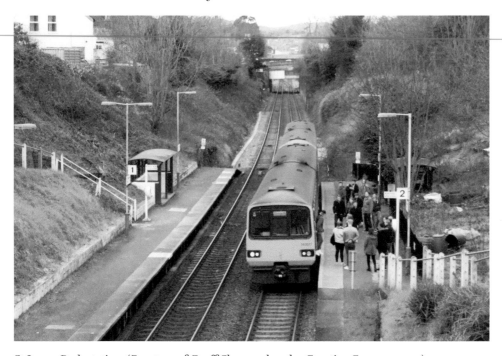

St James Park station. (Courtesy of Geoff Sheppard under Creative Commons 4.0)

K

Karno, Fred

> We are Fred Karno's Army,
> A Jolly lot are we,
> Fred Karno is our Captain,
> Charlie Chaplin our O.C.
> But when we get to Berlin,
> The Kaiser he will say,
> "Hoch! Hoch! Mein Gott,
> What a jolly fine lot
> Are the boys of company C!

These are some of the words to 'Karno's Army', sung by many a British Tommy during the First World War. By that time, Exeter-born Karno was well established as one of the leading theatre impressarios of the age. As the man who discovered Charlie Chaplin and Stan Laurel (of Laurel and Hardy fame), Fred Karno (1866–1941) was a household name.

Few people have had a greater impact on the development of the history of modern entertainment. He was born Frederick John Westcott in Paul Street, Exeter. It is true his family left Exeter for Nottingham when he was nine years old. Yet, despite this, he retained a sense of pride over his origins, which persisted throughout his life. 'Devon born and proud of it,' he would say.

Few children, even then, grew up wanting to be theatre impressarios, however, and so it should be little surprise Karno started out as an entertainer himself. Starting out as part of a group of three acrobats, the trio's act soon evolved to incorporate a number of skilfully timed, physically dexterous comedy routines. This experience became invaluable as Karno gradually grew more successful and moved into more of a managerial but nevertheless still very creative role. Karno is, even now, often credited with popularising the custard pie in the face routine beloved by clowns, proof of Karno's undoubted talent for self-promotion, even if this particular legend about him is probably not literally true.

Karno created a 'Fun Factory', a rich centre for writing and performing talent. He is credited with launching the careers of Charlie Chaplin, Will Hay and Stan Laurel. He became known as 'Guv'nor' to his stars.

A typical city store.

Stan Laurel fully appreciated Karno's impact on his career: 'Fred Karno didn't teach Charlie and me all we know about comedy, he just taught us most of it,' he later said. 'Above all he taught us to be supple and precise. Out of all that endless rehearsal and performance came Charlie Chaplin, the most supple and precise comedian of our time.'

Ironically, as many of the talents he discovered went onto become movie stars, Karno ultimately greatly boosted the growth of early cinema, thus accelerating the decline of music hall and precipitating his own downfall. He was declared bankrupt in 1927 and once again after an attempt to launch a new career in movies stalled in the 1930s.

Ultimately, Fred Karno died poor, but his role in the entertainment industry of the early twentieth century cannot be overlooked easily.

Film producer Hal Roach declared: 'Fred Karno is not only a genius, he is the man who originated slapstick comedy. We in Hollywood owe much to him.'

Kemp, Gene

A bright young woman goes to Exeter University before going on to become a successful children's author. It could almost be the story of J. K. Rowling.

Gene Kemp (1926–2015), born in Staffordshire, enjoyed her heyday somewhat earlier than the author of the Harry Potter books. She stayed in the university town for the rest of her long life, setting many of her books in Exeter, a city she loved.

More than forty years after it was first written, she remains best known for the novel *The Turbulent Term of Tyke Tiler* (1977), a winning formula with a joke at the start of every chapter and a twist towards the end. It was the first of a seven books set in the fictional Cricklepit School, which was directly based on St Sidwell's Primary School, Exeter, where Gene taught between 1963 and 1979 and was later a governor. The school even features a clock tower, something that features in Tiler's memorable final. The novel won Kemp a prestigious Carnegie medal. Other books in the Cricklepit series include *Gowie Corby Plays Chicken* (1981), *Charlie Lewis Plays for Time* (1984), *Just Ferret* (1990) and *Snaggletooth's Mystery* (2002). She received an honorary MA from Exeter University in 1984.

Gene, a dedicated socialist, produced over thirty books including *The Clock Tower Ghost* (1981), *Juniper* (1986), *Mr Magus is Waiting for You* (1986) and *Seriously Weird* (2003).

Kings in Exeter

Exeter can claim an association with many historic kings:

William I's (1066–87) nickname, 'the Conqueror', was well deserved: the Duke of Normandy won the Battle of Hastings and condemned England to the Norman Conquest – castles, Domesday Book and all. However, he struggled to conquer Exeter and was forced to besiege the city in person after it rose up in rebellion in 1068.

 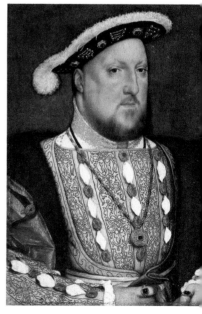

Above left: A pleasant area of Exeter today, Heavitree was once a notorious execution spot.

Above right: Henry VIII precipitated the break with Rome.

Stephen (1135–54) was a lesser-known monarch whose reign was dominated by a bitter civil war with his cousin, Matilda, who also had a good claim to the throne. This led to a bitter three-month siege of Rougemont Castle in 1137 after the Earl of Devon, Baldwin de Rivers, sided with Matilda and took it over, attacking Exeter initially after some residents appeared to side with Stephen. Stephen, who, reputedly, was already feuding with the earl anyway, immediately travelled to Devon and besieged the castle.

The castle's water supplies ran out quickly. Wine, however, remained in copious supply and was used by the castle's occupants as a drinking, cleaning and bathing substitute. The siege could not go on and the castle's occupants, weary, hungry and presumably drunk out of their skulls, soon surrendered. Stephen and de Rivers later made peace, while Matilda ultimately gave up her claim to the throne provided her son, Henry, could succeed Stephen on his death. In the end this is exactly what happened: he became Henry II in 1154.

Edward I (1272–1307), known as 'Longshanks' because of his height, Edward went to Exeter in 1285 to arbitrate in the trial following the Cathedral Green murder of Walter Lechlade. After the trial, Edward arranged for the city's cemetery to be enclosed by a wall incorporating seven gates as a security measure.

Henry VII (1485–1509) bequeathed a sword and a Cap of Maintenance to the city in gratitude for withstanding the siege of the pretender to the throne Perkin Warbeck in 1497.

Charles I: Exeter was very active on behalf of both sides during the English Civil War and Charles visited the city twice during the conflict. His daughter Princess Henrietta became the only royal personage ever to be born in Exeter in 1644.

Charles II (1660–85) spent one night at the deanery where he was richly and expensively entertained en route from Plymouth – where he had inspected the new Citadel – to London in 1670. Perhaps as a thank you, the king donated a portrait of his late sister Princess Henrietta to the Exeter Guildhall in 1671.

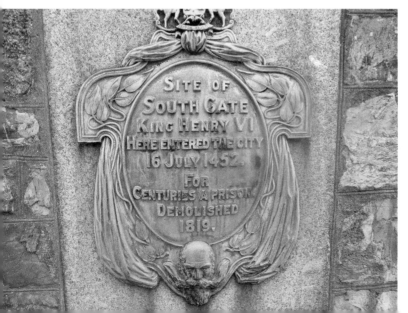

This plaque marks the site of the South Gate, which was demolished in 1819.

William III (1689–1702) or William of Orange's arrival in Exeter in 1688 occurred in dramatic circumstances. With the population increasingly alarmed by James II's open adoption of Catholicism, some including the Earl of Devon appealed to the Dutch Protestant Prince William (as he then was) to invade England and rule in his place. With fifty ships and 30,000 men, William, who was a grandson of Charles I and husband to James II's daughter Mary, landed in Brixham and established himself in Exeter where he attempted to establish himself and assess how much support he had.

How much support did William of Orange have? Initially, it seemed, not very much. The recent rebellion against King James led by the Duke of Monmouth in 1685 had ended badly for the rebels with the king seeking vengeance in the Bloody Assizes. Exonians were naturally cautious about potentially backing a loser in case the same thing happened again. Early arrivals from William's party thus initially found the West Gate of the city closed to them. William of Orange himself later arrived at Powderham Castle on a white charger. He was discouraged, however, when the dean briefly fled the city. A disappointed William contemplated abandoning the whole thing and returning his forces to Holland.

Gradually, however, the tide shifted in William's favour. As he marched on London, support for him grew and support for James evaporated. The king abdicated and fled. William III and Mary II ruled side by side in his place. A 'glorious revolution' perhaps, although, some would say, much more like an invasion or a coup.

George III's (1760–1820) visit to Exeter, accompanied by Queen Charlotte and three of his daughters in 1789, is often seen as the first 'modern' royal visit to the city. This is probably because, for once, the king was genuinely visiting the city, rather than attempting to besiege or take it over. The royal party was received at the site of the old East Gate and, after forming the core of a procession of tradesmen and other respected city figures, attended a service held in the cathedral. The king, at the time, was recovering from an early attack of one of the occasional bouts of mental instability, which ultimately completely overwhelmed him.

George V (1910–36) visited Exeter twice before he became king. The king and Queen Mary came to inspect a wartime hospital in 1915. It was the first time a reigning monarch had been driven by car through the city. 'After I am dead, the boy will ruin himself in twelve months,' George V once wrote of his son, Edward VIII. He was right: Edward did indeed abdicate within a year of succeeding his father in 1936. Edward's one visit to Exeter as king was brief too, though he was greeted warmly by cheering crowds of children as he was driven through from Whipton Bridge to Pocombe Bridge en route to Cornwall. He had twice visited Exeter as Prince of Wales, opening the County War Memorial on Cathedral Green in 1921 where he met 250 wounded war veterans on parade as well as an aged survivor of the 1850s Crimean War.

George VI (1936–52) had already visited the city as Duke of York. He passed through the city by train, soon after becoming king in 1937, attracting considerable crowds

The cathedral's distinctive pulpit.

This tree in Heavitree park was planted by George V and Queen Mary in the king's coronation year, 1911.

at St David's station. Despite this, it was the king and the future Queen Mother's visit to the city in the aftermath of the Exeter Blitz that earned them a special place in the hearts of many Exonians. The royal couple visited the Triangle at the end of the badly hit Paris Street and visited the Guildhall and the cathedral, which was still strewn with rubble after a direct hit on one of the side chapels. At one point, the king picked up and examined a large piece of shrapnel. The king and queen returned with Princess Margaret for a somewhat rainy visit in July 1950.

L

Exeter Combined Court Centre.

Lee, John 'Babbacombe'

On 23 February 1885, a young man, John Henry George Lee, faced the ultimate punishment. He had been found guilty of murder and faced death by hanging at Exeter Prison.

Yet things did not go according to plan. The phrase 'cheating the hangman' is usually associated with cases of someone dying by some other means before meeting their allotted fate at the gallows.

However, Lee did go to the gallows and yet he did not die. He escaped execution not once, not twice but three times when the gallow doors failed to open.

What had gone wrong? The executioner James Berry confirmed that he had tested the trap each time before attempting to open them for Lee. Each test had worked perfectly, but when it came to hanging Lee, the doors wouldn't open. Lee's reputation as 'the man they couldn't hang' had begun.

Even the authorities seemed fearful that some sort of higher power was at work. 'It would shock the feeling of anyone if a man had twice to pay the pangs of imminent death,' declared Home Secretary, Sir William Harcourt. Lee was sentenced to a life of penal servitude instead.

Public fascination with Lee's case has endured, not least because of a lingering suspicion that he was not actually guilty of the crime for which he had been convicted and that God was initiating an act of divine intervention to spare the innocent man from being executed unfairly.

In fact, there genuinely are solid, credible grounds for thinking he may have been innocent. The murder had occurred the previous November in the Devon hamlet of Babbacombe where Emma Keyse had lived in her home, 'The Glen'. On the morning of the 15th her body was found. The murder had been brutal. Her throat had been slit and there were wounds to her head. An attempt had also been made to burn the body.

Lee, who was the half-brother of the cook, was said to have been the only man in the house at the time of the killing. A former footman with a naval background and a past conviction for theft, investigators were alerted by an inexplicable wound on Lee's arm. Although he protested his innocence, 'The reason I am so calm is that I trust in the Lord and he knows I am innocent,' this purely circumstantial evidence was enough to get him convicted. He soon became known as 'Babbacombe' Lee, John Lee on its own not being a very distinctive name.

The mystery of Lee's survival is almost equalled by the mystery surrounding his ultimate fate after he was released from prison in 1907. Some say he died in a workhouse. More recent evidence suggests strongly that he emigrated to the United States, married and became a shipping clerk; indeed, it is now generally accepted that this is what happened to him. He is buried in Milwaukee, where he died, aged eighty, in 1945.

Lee's fame seems likely to continue to endure long after his death. In 1971, his life inspired a folk rock opera. One thing is certain: no one would ever forget John 'Babbacombe' Lee (1864–*c*. 1945), the man they couldn't hang.

Cricklepit Mill dates back to at least the thirteenth century. It was once owned by Nicholas Gervais, who built the first stone bridge across the Exe.

Martin, Chris

For a few years at the start of the twenty-first century, it was difficult to escape the music of Coldplay. Founded at University College London in 1996, the group were known as Pectoralz, then Starfish before becoming Coldplay. Thanks to hits like 'Yellow', 'In My Place' and 'Clocks', they remain one of the most successful British rock acts of the century so far.

Founder member, lead singer and guitarist Chris Martin is undeniably the group's most famous member and was born and has firm roots in Exeter. Born in 1977, he attended Exeter Cathedral School, where he formed his first band The Rockin' Honkies as a teenager. 'I was 15, wearing a long black coat,' Martin later said of his inauspicious musical debut. 'My voice hadn't broken, and my lyrics were appalling. Our first show was met with booing.'

Born in Whitestone, Martin enjoyed a comfortable upbringing and is the grandson of a former mayor of Exeter, John Besley Martin, who founded the long-running caravan and motorhome sales business Martins of Exeter near Clyst St George. This was sold by his father (now a retired accountant) in 1999. Martin was married to the Hollywood actress Gwyneth Paltrow between 2003 and 2016. Coldplay performed a number of early gigs in Exeter's Cavern Club in the late 1990s.

Museums

Exeter is a historic place but also has a good record of passing on historical knowledge to the public.

The Maritime Museum was a pleasant feature of the city's quayside between 1969 and 1997.

Exeter's main museum is the Royal Albert Memorial Museum and Art Gallery, commonly known as RAAM. It was founded in 1868 and was named in honour of Queen Victoria's husband, Prince Albert, who died in 1861. Between 2007 and 2011, the museum was closed as it underwent a £24 million redevelopment. In the years since it reopened, the museum has received widespread acclaim and a number of awards.

Special mention should also go to the Bill Douglas Cinema Museum, which opened in 1997. The museum, named in honour of the acclaimed British filmmaker Bill Douglas (1934–91), showcases over 80,000 objects relating to the world of cinema and film. It is located in the Old Library building on the University of Exeter's Streatham Campus.

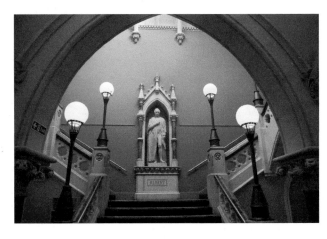

The RAAM reopened in 2011.

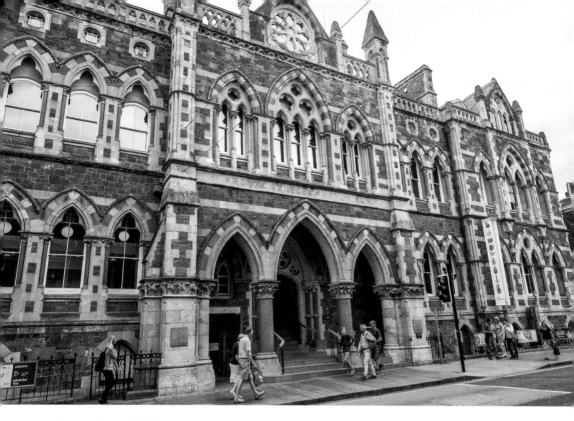

Above: The Royal Albert Memorial Museum (RAAM for short).

Below: Gerald the giraffe has always been a popular exhibit at RAAM. The original was killed by a big game hunter in Kenya in 1901.

Newspapers and Magazines

A number of notable newspapers and magazines have been produced in Exeter over the years.

In the nineteenth century the *Exeter and Plymouth Gazette* served as a leading Conservative Victorian newspaper run by Charles Wescomb.

In 1904, the *Express and Echo* newspaper was established, the result of a merger between the *Western Echo* and the *Devon Evening Express*. The newspaper has seen a number of changes in location and format over the years. For example, it reverted to the current tabloid format in 1979. It was a daily newspaper until 2011 when it became a weekly. Between 2015 and 2017, it was produced twice weekly (on Mondays and Thursdays) before becoming weekly again.

In a dramatic scene, the paper's High Street headquarters (now a Tesco) were badly damaged in the May 1942 Blitz. The morning after the raid, the editor held a 6 a.m. conference outside the office and production continued via a new printing press set up on tennis courts at Powderham Castle. After the war, the paper moved to Sidwell Street and Cheeke Street and then again to Sowton in 1992. In 2015 it relocated once more, from Heron Road, Sowton, to the city centre overlooking Gandy Street and Queen Street.

In 2012, Marc Astley, a former editor of the *Echo*, set up rolling news website, *The Exeter Daily*.

National home entertainment magazine *DVD Monthly* was published in Exeter between 2000 and 2009.

Exeter Living magazine started in 2005, and was created by Surf Media, which was then bought by regional media specialists MediaClash shortly afterwards. It's published every three weeks, has a circulation of 10,000 copies, and its focus is local independent businesses and other organisations.

Published by Archant, *Exeter Life* magazine began in around 2011 and grew from an occasional to a bi-monthly to a monthly magazine. It is sister magazine to *Devon Life*.

Grow Exeter is a business-orientated magazine. It was founded by Daniel Frye (CEO) and Llewellyn Nicholls (CCO) in 2017.

The Met Office currently employs around 2,000 people.

Heavitree News was started in January 2002 by former sports journalist Martyn Beckett. It ran monthly until it was subsumed briefly into an Exeter-wide publication, *The Voice of Exeter*, in 2009. Seven years later Martyn Beckett restarted it as a quarterly in late 2016. He handed it over to Tom Fairfax on his retirement in December 2018. The *One Magazine* actually has six different local editions, the first of which began in Exmouth in 2006. The Exeter editions came three to four years after that under the name *City Press for Exeter*. The name was changed to *One Magazine* in 2012 when we started to add on more editions and wanted one brand to go across the whole range — hence One. It was started by Paul Veysey as a one-man band from his shed in the bottom of his garden, who ran it until October 2017 where he then retired and sold the business.

O

(The) Onedin Line

Older readers won't need any introduction to this popular BBC period drama of the 1970s, *The Onedin Line*. Based around the varying fortunes of a fictional Victorian shipping company, Cyril Abraham's series made household names of its stars Peter Gilmore, Anne Stallybrass and Howard Lang, as well as then rising young actors like Jane Seymour and Warren Clarke. The show ran for ninety-one episodes between 1971 and 1980.

Although set in Liverpool, Exeter Quayside served as the backdrop for many of the show's set at the Liverpool docks. With historic buildings like the Custom House and the Prospect Inn adding authenticity to proceedings, many city residents will have memories of filming taking place. Changes to the layout of the Quayside since the 1970s would today make it less suitable for filming such a programme.

The historic quayside.

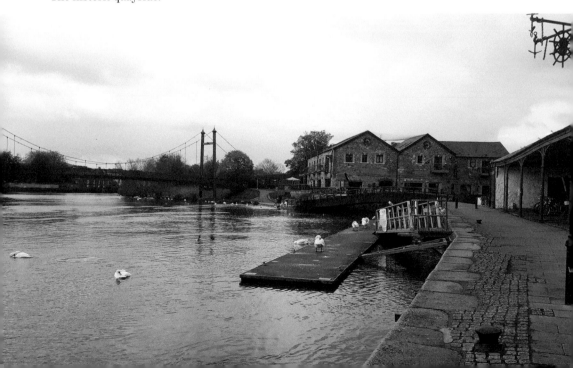

P

Plague

Although historical detail on the outbreaks is perhaps mercifully rather lacking, the several outbreaks of plague to hit the city in medieval times were probably the worst things to ever happen in Exeter.

Just as the disastrous 1918–19 influenza pandemic was contributed to by the return of servicemen from the First World War, the return of warriors from the Sixth Crusade probably helped facilitate the spread the plague to many areas including Exeter in 1234. It is thought more than two-thirds of the city's population died. Life for the remaining 30 per cent (or so) during this dark period could not have been very pleasant either.

In 1349–51, the survivors' great-grandchildren went through much the same thing when the Black Death hit the city with particular severity. This time, half of the city was wiped out. A further third were killed when the plague returned eleven years later. Among other things, the outbreaks led to a delay in the competition of the construction of Exeter Cathedral. In general, it is believed the global population fell

Hotel du Vin, previously known as the Magdalen Chapter, and before that Hotel Barcelona. Once Magdalen Hospital, lepers were once treated on the site.

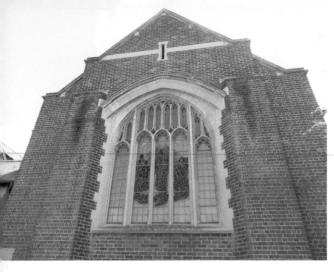

Pinhoe Road Baptist Church.

St Mark's Church, situated in Pinhoe Road.

from 450 million to 375 million as a result of the Black Death, with the population not returning to its previous level for around 200 years.

The plague returned again in 1479–80 and again (now after the medieval era) in 1542, claiming the life of the father of John Hooker among many others. The city braced itself for the arrival of the Great Plague in 1665. Preparations were made and fear was widespread. Mercifully, this time Exeter was spared.

Exeter has also been subject to other periodic outbreaks of disease. Just over 400 people were killed by a cholera outbreak in Exeter and St Thomas in 1832.

Princesshay

Packed with a heady array of shops and restaurants, Princesshay shopping centre is an unmissable feature of the modern city. It was opened by the young Princess Elizabeth (late Elizabeth II) in October 1949, she being the 'Princess' from which Princesshay

Next, at the edge of the Princesshay development.

takes its name. It effectively replaced Bedford Circus, a pre-war shopping area that was replaced as a result of a combination of the Second World War bombing and post-war redevelopment plans.

It was the first pedestrianised shopping street in the country. Post-war Princesshay ran from Bedford Street to Eastgate House, roughly parallel with the High Street. It also covered the entire post-war development on the south side of the High Street between Paris Street and the cathedral precinct, north of Southernhay.

Princesshay was, in a sense, born again in 2007 when after a two-year period of rework it emerged as a thriving twenty-first-century retail zone dominating the area between Southernhay and Cathedral Green. In May 2008 an attempted terrorist attack in the district's popular Giraffe restaurant effectively failed, injuring only the attempted bomber, who was subsequently jailed.

Ironically, an unexpected side effect of all this modernisation was the discovery of a rich array of archaeological artefacts when work began on the new Princesshay in 2005.

Prison

One building that most people will want to avoid visiting is Exeter Prison. According to the great Exeter historian W. G Hoskins, the building was completed in 1818 to replace the notorious South Gate prison, 'one of the foulest holes in England'. Many other sources suggest construction was completed closer to the mid-nineteenth century and was designed by local architect John Hayward, who modelled it on the more famous Pentonville. The prison played host to a number of executions in the nineteenth century including the botched hanging of John 'Babbacombe' Lee, the notorious 'man they couldn't hang' in 1885. In 2019 around 450 prisoners, all male, were in Exeter Prison.

Exeter has been besieged ten times during its long history.

Queens in Exeter

A number of queens have had associations with Exeter.

There have only been six female monarchs in English history: Mary I, Elizabeth I, Mary II, Anne, Victoria and Elizabeth II. In the period since the Norman Conquest, less than 200 years have been spent under the rule of queens. The 2013 Succession of the Crown Act has ensured that from now on the oldest child of a monarch will become heir to the throne regardless of gender. Despite this, the remainder of the twenty-first century seems likely to be dominated by kings with Charles III, William V and George VII in line to follow Elizabeth II.

The Tudors had little to do with Exeter. Interestingly, however, Catherine of Aragon stayed in the city for a few days en route from Spain to marry Arthur, the Prince of Wales, in 1501. Disturbed by a persistent noise during a stormy night, an offending creaky weathervane had to be removed from St Mary Major Church during her stay.

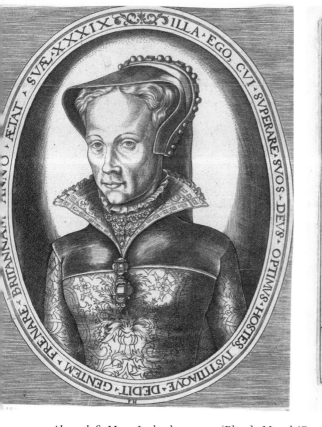

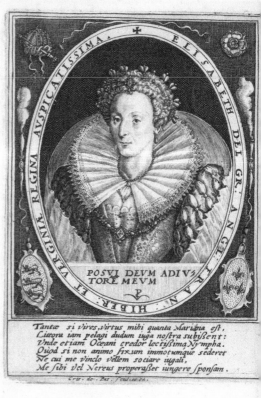

Above left: Mary I, also known as 'Bloody Mary'. (Courtesy of the Rijksmuseum)

Above right: Elizabeth I conferred Exeter's motto on the city, although she never visited herself. (Courtesy of the Rijksmuseum)

The same man had to do the dangerous climb to reinstate the vane after the Spanish princess left Exeter.

Catherine's domestic life was to prove less easy to fix, however. Prince Arthur died five months after the marriage and Catherine married his brother Henry instead. In 1509, he succeeded to the throne, becoming Henry VIII. Catherine gave birth to the future Queen 'Bloody' Mary but when Henry later sought to declare the marriage invalid, he precipitated the break with Rome, triggering the English Reformation in the process.

Henry's second daughter, Elizabeth I (1558–1603), never actually visited Exeter but was nevertheless grateful to the city for its role in helping defeat the Spanish Armada in 1588. 'All my best men come from Devon', she once said, and recommended the motto '*Semper Fidelis*' ('ever faithful') for the city, a slogan that wore slightly thin after Exeter switched sides several times during the English Civil War in the next century.

Surprisingly, Queen Victoria never made an official visit to Exeter during her entire reign (1837–1901). She did visit several times unofficially as both princess and queen, however. In particular, she and Albert were greeted warmly with three bouquets of flowers after being forced to make an unscheduled stop in Exeter, after a bout of seasickness led her to abandon a trip to Plymouth. The Royal Albert Memorial Museum (RAAM) was, of course, named in honour of Prince Albert, who died in 1861.

Above left: Queen Victoria was Britain's second longest-reigning monarch. Since 2015, Elizabeth II has been the longest-serving queen.

Above right: Queen Victoria, now the second longest-reigning British monarch.

There is also a statue of the queen in Queen Street, a street opened in 1839, two years after Victoria ascended to the throne.

Under Elizabeth II, Exeter has enjoyed more royal visits than ever, all thankfully much more peaceful. As Princess Elizabeth, she toured some wartime army barracks in 1944 and returned to visit the rebuilding of the bombed city centre in 1949. She was the 'Princess' after which Princesshay is named.

The year 1956 saw her first formal visit to Exeter as queen; indeed, it was the first ever formal royal visit to Exeter by any reigning queen. She returned to the city in her silver jubilee year of 1977, and again in 1979, when she left by plane from Exeter Airport.

Her next visit, in 1983, was notable for incorporating the traditional distribution of Maundy Thursday gifts in a ceremony broadcast on BBC Radio 4 from Exeter Cathedral.

The Queen returned to the city for her golden jubilee year of 2002 and in her diamond jubilee year of 2012. Other royals such as Princess Anne, Prince Charles and the late Diana, Princess of Wales, have also visited on a number of occasions.

R

Railways

In the history of Exeter, 1 May 1844 was a historic day. For it was then that the first passenger train, drawn by the steam locomotive *City of Exeter*, pulled into the newly completed St David's station, having travelled from Bristol. A banquet was thrown to celebrate. The man who had constructed the line, the great engineer Isambard Kingdom Brunel (who was only just over 5 feet in height when not wearing his usual 8-inch tall top hat), stood on a table to acknowledge the crowd's applause. Other landmarks lay in the future.

In 1848, the London & South Western Railway planned a line from Yeovil in Somerset to a proposed 'central station'. In 1860 services began with two trains to and from London Waterloo a day and one to and from Yeovil. York Road and Blackall Road were built purely as approach roads to the new station. The original plan had been to run the line along the Chutebrook Valley to the quay with the main station being built in Barnfield. Other changes had already occurred. Since 1851 visitors had been able to travel by train to Plymouth and from there to London.

In 1862, St David's and Central stations were linked by a tunnel under St David's Hill. The two stations were connected for the first time. It has been claimed that there is no steeper slope between Exeter and London than the area between the two. The Rougemont Hotel was built opposite Queen Street station in 1876 specifically to cater for rail passengers.

In 1880, the Definition of Time Act imposed a standard time on the whole UK, necessitated by the development of the railways. Bizarrely, Exeter had been fourteen minutes behind London until this point as it was 3.31 degrees west on line of latitude, local time. The Dean of Exeter, however, had been persuaded to move the cathedral clock forward as early as 1852 while St John's Church in Fore Street had a clock showing two different times, standard and local, for many years.

The idea that times would vary from town to town might seem odd to us today, but it had applied throughout the country until this point. It is not as eccentric as it sounds: different countries, of course, exist in separate time zones to this day (sometimes with several in one country). The move towards a standard time obviously made the train service easier to operate and also represented a significant step towards unifying the country.

Times were changing in other ways too. In 1883, Exeter Tramways extended their horse-drawn service all the way to Mount Pleasant.

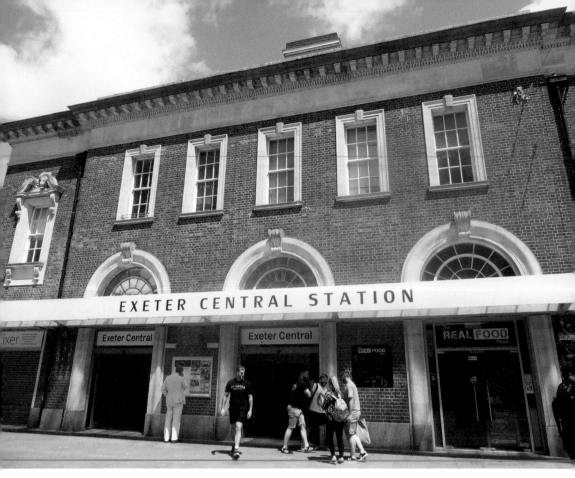

Exeter Central station, the city's second biggest train station.

In short, by the end of the nineteenth century, Exeter had established a basic public transport system. The trams are, of course, now long gone but despite the savagery of the Beeching Report cuts in the 1960s, Exeter's public transport system remains strong today.

However, there was a downside to the development of rail: whereas some places were transformed for the better by connecting to the rail network, Exeter had effectively been bypassed long before the construction of its first railway station.

The Georgian golden age was gone, never to return.

Rowling, J. K.

As the creator of the hugely successful Harry Potter series, Joanne Kathleen Rowling (b. 1965) is the most successful author in the world today. Rowling has written other books but it is the world of Potter, which has famously transported readers to a world peopled by Tri-Wizard Tournaments, rampaging trolls and battles between good and evil, that she is most famous for. Many people have come to feel it was inspired by Exeter.

This might seem a bit odd. The trains coming into Exeter St David's station do not fly after all. The stadium at Sandy Park has never played host to a Quidditch

Tournament. Nor do the pictures on the front of the *Express* and *Echo* come to life as you look at them.

However, Rowling did study Greek and Roman Studies at Exeter between 1981 and 1986, having switched from French. This was an important period in her development. She had an article published in the university journal *Pegasus*, based on her experiences studying Classics, entitled 'What Was the Name of That Nymph Again?'.

Let us be clear: Rowling was born in Gloucestershire, nearly 100 miles from Exeter. She didn't write any of her major works such as the Potter or Cormoran Strike series while she was a student. Despite this, aspects of her time in Devon have clearly found their way into her books. The character of Dawlish, the house elf, clearly owes his name to the nearby seaside resort, while sections of the books are even set in Devon such as the Weasley family's lives in the fictional Ottery St Catchpole. Dumbledore's gold watch with its circling moon and sun also seems likely to have been inspired by the clock in Exeter Cathedral. A number of streets and local buildings are thought to have fictional counterparts in the books and films too. A Harry Potter-themed bar, The Cauldron Inn, opened on Gandy Street in August 2017.

It is probably fair to say that without Exeter, the Harry Potter phenomenon would not exist in the form that we know it today.

Church Cottage, Tutshill, Gloucestershire, was the childhood home of author J. K. Rowling.

Southcott, Joanna

From Nostradamus to Mystic Meg, history has been full of people who have claimed they have the power to foresee the future. One such person was Joanna Southcott (1750–1814), the self-proclaimed 'Prophetess of Exeter'. She and her box soon became very famous.

Joanna's story began ordinarily enough. Born to a small farmer in Taleford in Ottery St Mary, she worked for many years as a domestic servant in Exeter, a career that only came to an end when she sued her employer for sexual harassment. The case was way ahead of its time, not so much because Joanna was sexually harassed (something that has sadly never been unusual) but because she was able to do something about it. She won the case, representing herself at the Guildhall. A devout Christian and Methodist, Joanna soon developed her public speaking career further, preaching to the multitude and developing a belief that God was literally speaking through her.

Some of her prophecies were more impressive than others. For example, she foresaw the deaths of the politicians Charles James Fox, William Pitt the Younger, the King of Sweden and Louis XVI, although as nearly everyone who had ever lived had ended up dying by that point (as, indeed, has nearly everyone since) this was perhaps unremarkable, particularly as Louis XVI's life was already imperilled by the ongoing French Revolution. In fairness, however, she also reportedly predicted a rise in grain prices, the French invasion of Italy and the madness of George III (as in the king's illness, not the later Alan Bennett play), all of which were less predictable and all of which came to pass.

Tiring of Exeter, she and her followers soon moved to London where in addition to her pamphlets predicting the future, she began selling 'seats of the Lord', which it was claimed would ensure the holders' places among the 144,000 people who would be elected to eternal life. She also began prophesising that she was pregnant and that she was herself a woman referred to in the Book of Revelations destined to give birth to a boy named Shiloh, who would one day be a great ruler. 'Shiloh' was in fact a place name, not a boy's name plucked apparently randomly from the Bible. Joanna, now in her sixties, did not give birth. She died.

This was not quite the end, however. Following such a success, it soon became hard to keep prophets down. On her death, the Irish preacher John Ward started claiming to be Joanna's earthly successor. Her followers continued to argue that her box of

prophecies that she had left behind should one day be opened as they might unleash the key to the Earth's survival during the final millennium. Such appeals were still being made as late as the 1930s.

Sadly no one ever found Joanna's box, the whereabouts of which are now unknown.

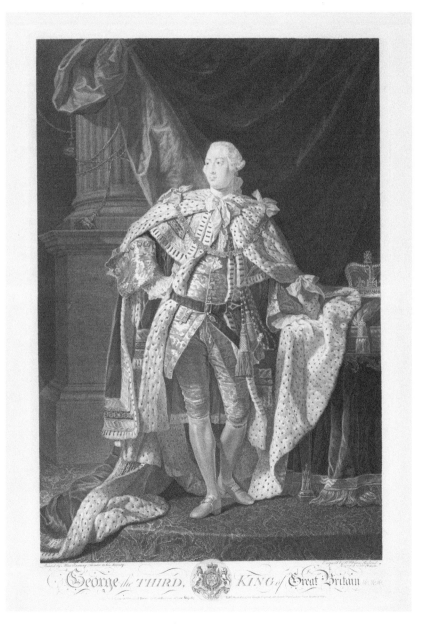

Mad King George III. (Courtesy of the Wellcome Collection)

Temple, William

In October 1944, news came through that the Archbishop of Canterbury, William Temple, had died.

The news, for most of the public, was sad, but not devastating. This was 1944 and most people were preoccupied with the ongoing struggle to win the Second World War, but there is undeniably something tragic about the timing of Archbishop Temple's demise. Within a year of his death, not only had victory been achieved over both Nazi Germany and Japan, but a new Labour government had been elected, with an overwhelming mandate to deliver a welfare state and a full National Health Service for Britain's war-weary citizenry. 'Let Us Face The Future Together', proclaimed Michael Young's manifesto for the party. One does not have to share that political outlook to still feel it is a shame that Temple died at the very point when such a monumental effort to achieve the goals for which he had tirelessly fought all his life was about to be undertaken.

William Temple is the only Archbishop of Canterbury to have been born in Exeter. He was not the only Archbishop of Canterbury within his own family, however. His father was Frederick Temple, Bishop of Exeter, and William was actually born in the Bishop's Palace in 1881. His father would later be appointed as the last Archbishop of Canterbury of the Victorian age. He was ordained himself in 1908, a few years after his father's death. Plagued by gout and bad eyesight throughout his life, Temple nevertheless pursued successful careers in academia and the church, serving as headmaster of Repton shortly before the First World War, before becoming Canon of Westminster, Bishop of Manchester, Archbishop of York and then finally Archbishop of Canterbury in 1942.

In 1942 he also published his key book *Christianity and Social Order*. Today, the William Temple Foundation website states:

A single page in this book outlines the contours of the Welfare State with its call for the provision of universal access to healthcare, education, decent housing, proper working conditions, and democratic representation. William Temple's vision of a post-war society that reflected the innate dignity of each person created in the image of God (imago Dei), was hugely influential on William Beveridge, impacting on the 1942 Beveridge Report which lead to the establishment of the Welfare State in 1945.

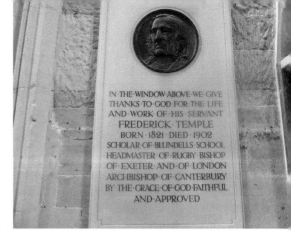

A memorial to the Archbishop Temple's father, who was also a bishop in the cathedral.

Temple was an active member of the Labour Party and had played an active role in mediation during the 1926 General Strike. His life ended just as many of the socialist ideals that he had spent much of his life campaigning for were about to be implemented. He was succeeded as Archbishop of Canterbury by Geoffrey Fisher, who would later crown Elizabeth II at Westminster Abbey in 1953.

Theatres

According to historian Hazel Harvey, Exeter was the first place to mention a theatre in England. Less happily, it can also claim the worst disaster in English theatrical history (see: Fire: 1887 Theatre Royal Fire).

Between the 1830s and the 1960s, there were three consecutive theatres known as the Theatre Royal in Exeter. The first developed from what was previously known as the Bedford Circus Theatre, which had replaced a previous theatre that had burned down in the 1780s. Fire was common then. The first Theatre Royal was destroyed by fire with no loss of life in 1885. The second burnt down calamitously in 1887.

The third Theatre Royal was more successful and was noted for its unusually long run of pantomimes. The theatre continued from 1889 until it was closed in 1962. A campaign to save it failed, and an office block was built in its place. George Vernon Northcott (1891–1963) had been among those fighting to save or seek an alternative future for the theatre.

The Northcott Theatre, which has existed on the Streatham Campus of the university since 1967, was built as its replacement and was named in his honour. The theatre opened with a production of *The Merchant of Venice*. Barbara Hepworth unveiled one of her sculptures in the foyer on the opening night. In 2007, the theatre underwent a major renovation, although was simultaneously threatened with closure when the Arts Council briefly threatened to withdraw all funding.

The Barnfield Theatre in Southernhay, meanwhile, has been in operation since 1972.

The Phoenix Arts Centre, as it is now known, is situated at the top of Upper Paul Street. It was first built in 1911 for the University College of the South West, remaining in university use for some years after the 1950s before becoming the arts centre. It enjoyed a major refit in 1999.

Underground Passages

Medieval Exeter had its share of problems, one of which was to do with water. The city in the thirteenth century struggled to provide its populace with enough of the essential liquid because, as author Derrick Warren explains, 'there were strong springs to be found outside the city walls, but because Exeter was built on a low hill, water could not be brought to parts of the city in open runnels by gravity'.

It was thus decided to build a series of underground tunnels through the hill through which lead pipes could carry water in. The pipes often leaked and repairs to buried pipes could only be carried out by digging them up. The tunnels themselves were often made from the natural rock through which they had been cut and were generally from 3 to 15 feet in height. The earliest ones date back to the year 1245.

The passages are today obsolete, but enough of them survive to ensure that they can be visited in regular organised tours. This subterranean medieval world can be accessed via Paris Street.

University

Exeter University has an impressive track record. It would be easy to overwhelm readers with statistics detailing its success at this point. Such figures are certainly easily accessible, are available in abundance and are certainly no less impressive or well earned for being statistics. However, such figures not only tend to date badly (I am writing these words in May 2019, but some readers may be reading this in September 2050, after all) and tend to go in one ear and out of the other. So, it's probably important to emphasise only a few points in a systematic academic fashion.

Point one: the university has grown rapidly in both size and scope since it was first established in 1955. The young Elizabeth II granted the royal charter to the university in a ceremony at Streatham Campus. But while the university itself is comparatively new, its origins are older. It effectively replaced the University College of the South West, which was made up of the Exeter Schools of Art and Science established around a century earlier. Since then, as with other universities, numbers have expanded

dramatically. There were fewer than a thousand students at Exeter in the mid-1950s. Sixty years later there were over 20,000.

Point two: the university is genuinely successful. It has maintained a top-ten position in the National Student Survey since the survey was first carried out in 2005. Sources also indicate that the annual income of the institution for 2017–18 was £415.5 million. It is undeniably both a major source of income and employment. This will probably still be true in 2050 (if you are reading this then, please adjust the above figures in your head accordingly).

Point three is harder to measure. The university has undoubtedly had a major impact on the life of the city, often attracting young people who have stayed here for the rest of their lives. Others have left the city, going on to achieve higher things elsewhere.

Two students have a look at the Royal Charter in the 1950s. (Reproduced with the permission of the University of Exeter)

Students studying in the Roxborough Library in 1959. (Reproduced with the permission of the University of Exeter)

Students tuck in at the Devonshire House refectory in the early 1980s. (Reproduced with the permission of the University of Exeter)

Exeter University has had all manner of subsequently big names pass through its corridors over the years and the decades ahead are sure to see many more. Some of Exeter's most famous graduates are discussed elsewhere in this book. Below are just some of the others who have achieved fame.

Robert Bolt (1924–1995) achieved a teaching diploma before winning two Oscars as the screenwriter for *Doctor Zhivago, Lawrence of Arabia* and, most famously, *A Man For All Seasons*. He was twice married to the actress Sarah Miles.

Steve Bell (b. 1951), known for his ingenious, often bizarre 'If...' cartoons in *The Guardian*, trained to be an art teacher in 1975 at what later became St Luke's Campus.

Andrew Lansley (b. 1956) was elected Tory President of what is now the National Student's Union while studying Politics at Exeter in the 1970s. He later became Health Secretary under David Cameron (2010–12).

Caroline Lucas (b. 1960) became Britain's first ever Green MP in 2010. She led the party between 2008 and 2012 and again after 2016. She got a First in English from Exeter in 1983.

John O'Farrell (b. 1962), the comedy writer and author of the book *Things Can Only Get Better*, studied English and Drama.

Rhod Gilbert (b. 1968), the Welsh comedian and panel show regular, studied Languages. He has since recalled being very shy during his time at Exeter.

Abi Morgan (b. 1968) studied English and Drama before becoming an acclaimed TV and film writer, creating BBC series *The Hour* and writing the screenplays for the films *Brick Lane* and *The Iron Lady*.

James Brokenshire (b. 1968) obtained a degree in Law. He succeeded fellow Exeter alumni Sajid Javid (see below) as minister of Housing, Communities and Local Government in 2018.

Sajid Javid (b. 1969) read Politics and Economics between 1988 and 1991 and joined the Conservative Party while studying at Exeter. He was appointed Home Secretary in 2018 and contested the party leadership the following year.

Steve Backshall (b. 1973), presenter on wildlife shows such as *Deadly 60*, studied English and Theatre Studies.

Actress Vanessa Kirby (b. 1986) studied English. Amongst other roles, she later played the young Princess Margaret in TV's *The Crown*. Her onscreen husband Antony Armstrong-Jones was played by Matthew Goode, who was also born in Exeter.

Princess Anne's children, Peter Phillips (b. 1977) and Zara Tindall (b. 1981) went to Exeter too. Peter graduated in Sports Science in 2000 and future Olympic silver medallist Zara graduated in Equine Science and Physiotherapy in 2002.

Recreation time. (Reproduced with the permission of the University of Exeter)

Violet and Irene Vanbrugh

In late nineteenth-century Exeter, two actresses were born who would go on to enjoy successful stage and screen careers well into the twentieth century. They were sisters and though they were born with the surname 'Barnes', they would achieve success with a new surname. They were Violet (1867–1942) and Irene (1872–1949) Vanbrugh. Their lives are commemorated with a blue plaque at the walkway between Roman Walk and Southernhay, close to the site of the house where Violet was born. Irene was born in Heavitree. The actual house where Violet was born was demolished as a result of German bombing during the Second World War.

Both girls attended Exeter High School. Violet launched herself into acting soon after, in defiance of her vicar father's wishes. Influenced by the famous Dame Ellen Terry (who encouraged her to change her name), Violet quickly developed a reputation as a

The Vanbrugh sisters are still remembered today.

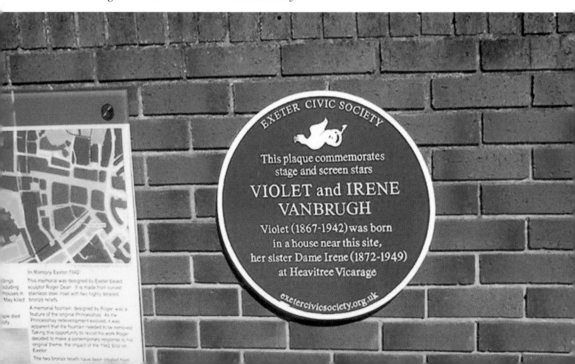

strong Shakespearian actress. She married the actor Arthur Bouchier, who managed her. The two had a daughter, Prudence Vanbrugh, who also became an actress. As she grew older, Violet became a noted film actress too. A role in the George Bernard Shaw's 1938 film *Pygmalion* was one of the last great roles of her distinguished career.

By that time her younger sister Irene had followed her onto the stage, achieving perhaps even greater success performing in plays written by J. M. Barrie, Sir Arthur Wing Pinero, Somerset Maugham and Oscar Wilde. Irene 'set all London on fire' with one performance, according to one review. Appearing before George V and, later, Queen Elizabeth, the future Queen Mother, Irene was later made a Dame. She too married, although had no children. Her films included *The Rise of Catherine the Great* (1938) and *I Live in Grosvenor Square* (1945) with Rex Harrison.

In their final years, the two actresses teamed up to deliver a number of morale-boosting turns on stage during the Second World War. For all their success, the Vanbrugh sisters never forgot their origins and frequently returned to Exeter or Devon during their careers.

Visitors

In addition to those who were trying to invade, besiege or drop bombs out of planes onto it, Exeter has enjoyed a distinguished range of visitors over the years.

The famous traveller Celia Fiennes visited in 1698. 'Exeter is a town very well built,' she observed. 'The streets are well pitched, spacious noble streets, and a vast trade is carried on.' Fiennes was impressed by the city's booming wool trade.

Daniel Defoe, the author of Robinson Crusoe, came to the city in 1724. He liked it, observing, 'tis full of gentry and good company, and yet full of trade and manufacturing also'.

Writer Fanny Burney accompanied George III on his visit in 1789. She was less keen and found the city 'close and ugly'.

Poet Robert Southey visited in 1799 and wasn't impressed either. 'Exeter is an ancient city and has been so slow in adopting modern improvements that it has the unsavoury odour of Lisbon', he wrote, condemning both Exeter and the capital of Portugal with one stroke. 'One great street runs through the city from east to west, the rest consists of dirty lanes.' Admiral Nelson dropped into the Royal Clarence in 1801 while Hungarian composer Franz Liszt gave a piano recital there in 1840.

Middlemarch George Eliot observed the Guildhall in 1852: 'a very old bit of building, apparently Saxon, which appeared to be used as a Police Station'. Children's author and Peter Rabbit creator Beatrix Potter stayed at the Royal Clarence Hotel during a visit in 1892.

The great cricketer W. G. Grace played at Devon Cricket Ground off the Prince of Wales Road in around 1900.

Author Thomas Hardy stayed with his second wife, Florence, at the Royal Clarence Hotel in 1915, also popping into the RAAM (the museum) during his stay.

Less happily, Sir Oswald Mosley and his Blackshirt cronies held a rally at Belmont Park in 1930s. Today, in stark contrast, the same park plays host to the Exeter Respect Festival.

Hollywood stars Clark Gable and Gary Cooper both stayed in the Royal Clarence Hotel at different times during the Second World War. Gable, best known for his role in *Gone With The Wind*, was serving with the US Airforce. Cooper, later in *High Noon*, was entertaining troops stationed there before D-Day.

Actors Jimmy Edwards and Diana Dors both visited the Prospect Inn in the 1950s and 1960s. Both were famous by this point and appeared as specially invited guests (not just as regular pub users!) The Beatles performed three concerts at the ABC Cinema in 1963–64. They stayed at the Rougemont Hotel.

David Bowie performed at what was then Tiffany's nightclub in Commercial Road at the dawn of his career in 1969.

Some scenes of the classic comedy series *Monty Python's Flying Circus* were filmed in Exeter. The famous comedy troupe filmed some scenes from the fourth and, as it turned out, final series of the legendary TV comedy in the city, with the gang staying at the historic White Hart pub in South Street.

The fifteenth-century White Hart once played host to the Monty Python team.

As Python Michael Palin recalled in his diary entry for Sunday 8 September 1974:

Arrived at 8.30 at the White Hart Hotel in Exeter. An historic inn, with its history quite spectacularly displayed – beams, torture instruments on the wall, cannon etc. but a fairly cosy, un-smart bar, where Ian, Eke, Graham and John and Douglas (Graham's writer friend from Cambridge) all others all sat. Palin, Michael, *The Python Years: Diaries 1969–1979* (Orion, London, 2006), p. 209

Among others present were Graham Chapman and John Cleese, while 'Graham's writer friend' was Douglas Adams (1952–2001), then twenty-two, the future author of comedy sci-fi classic *The Hitchhiker's Guide to the Galaxy*. Though unknown then, Adams was a keen Python fan and played a small role in the last days of the series, filling in for the equally tall John Cleese who had by then ducked out to make his own sitcom *Fawlty Towers* with his then wife Connie Booth. The Pythons filmed various sketches in Southernhay, the High Street and elsewhere. Palin also recalls he and Eric Idle enjoying a silly practical joke in a woman's panty shop on a quiet afternoon when the weather had prevented further filming.

Huge crowds gathered to receive controversial music legend Michael Jackson when he visited the city in June 2002. In a rather surreal scene, Jackson appeared before a crowd of 7,000 on the pitch of St James' Park alongside magician David Blaine and acclaimed spoon-bender Uri Geller. A co-chairman of Exeter Football Club, Geller, a good friend of Jackson's, had engineered the appearance as a means to raise funds. Never previously known for liking soccer or even for being sporty, Jackson reportedly enjoyed the occasion. 'I'm a soccer fan now, definitely', Jackson said. 'It was so exciting and passionate – the fans were like the people who come to my concerts ... I wanted to jump up and start dancing because I'm used to performing on stage when I hear all that noise.'

Warbeck, Perkin

Who on Earth was Perkin Warbeck? Perhaps the question 'who wasn't Perkin Warbeck?' would be more appropriate. Perkin Warbeck (1474–99) was pretty much nobody, but he assumed importance in the late fifteenth century by pretending to be Richard of Shrewsbury, the second son of Edward IV and one of the two famous 'princes in the Tower'. The princes (the oldest of whom was, in fact, no longer really a prince but the boy Edward V) famously went missing and were presumably murdered while under the 'protection' of their uncle, who became Richard III in 1483 and who was himself overthrown by Henry Tudor in 1485. In 1497, as part of his campaign to become established as Richard IV, Warbeck led 5,000 men into Exeter in 1497, shortly before being defeated by Henry VII and ultimately captured and executed.

Much later, in 1674, under Charles II, two skeletons, later established to have been the right age and size to have been the two princes, were discovered in the Tower. Although we can probably safely assume it was them, it is unclear if they were murdered and, if so, by whom. As beneficiaries, Richard III or Henry VII (or, to be precise, men acting on their orders) are usually seen as the prime suspects.

Although he was about the right age to have been Prince Richard, Perkin Warbeck's claim was always weak. Even if Warbeck had been Prince Richard – and we can now say with confidence that he definitely wasn't – his claim to actually be the rightful Richard IV was dependent on his own brother, young Edward V, having somehow died while he, supposedly although not actually, the other prince, had lived.

The fact that Warbeck successfully caused so much trouble for Henry VII for several years tells us two things: first, that Henry VII's grasp on power must have been very tenuous indeed during the early years of his reign following his victory over Richard III at the Battle of Bosworth in 1485, and second, that Perkin Warbeck must have been a very charismatic, persuasive figure in his own right. There were, of course, no cameras, newspapers or TV then and so the identity of a prospective claimant was harder to verify. With no real evidence to back him up, it must be assumed that Perkin really had something about him to persuade so many people to support his cause.

As it is, like Lambert Simnel before him, Perkin Warbeck will always be remembered as a pretender to the throne.

Witches

The late seventeenth century was not an easy time for Exeter or, indeed, anywhere else. In the 1680s, James Scott, the Duke of Monmouth, launched a rebellion against James II. Monmouth was the oldest illegitimate son of the king's late brother, Charles II, so may or may not have had a good claim to the throne, but as was so often the case back then, religion was the real issue. We now know the Catholic James II would actually be driven out by the Dutch Protestant William of Orange quite soon afterwards in 1688, but Monmouth's forces were less fortunate. They were defeated at the Battle of Sedgemoor in Somerset in 1685. Monmouth himself was executed and eighty people in Exeter were hanged, drawn and quartered at the Heavitree gallows after the notorious Judge Jeffreys held one of the Bloody Assizes at Exeter Guildhall. These Bloody Assizes were essentially special courts set up to punish the local populace in the aftermath of the Monmouth Rebellion's failure. The remains of the dead were hung from trees to serve as a horrible warning to anyone else considering rebelling against the monarch in the future. This partly worked: many Exonians were initially wary of supporting William of Orange for this reason three years later.

As if all this religious violence was not unpleasant enough, Heavitree's gallows were also kept busy by the execution of three old ladies accused of witchcraft around this time. Temperance Lloyd, Susannah Edwards and Mary Trembles, all from Bideford, confessed to a range of unlikely sounding crimes including consorting with the Devil, who apparently took the form of a small black man, and deliberately pricking leather so as to induce pains in the knees of local people in 1682. It is unclear how exactly these symptoms, if they ever existed in the first place, were caused by the pricking of leather or whether they ended with the executions. One would suspect not.

Later, Alice Molland was executed at Heavitree in 1685 and is sometimes cited as the last woman to have been executed for witchcraft in England, although there seems to be some evidence contradicting this. At any rate, the tragic wave of witch-hunting hysteria was at least nearing its end even if the death penalty for witchcraft wasn't formally abolished in England until 1736.

Timepiece nightclub opened in 1993. It is on the very site where the accused seventeenth-century witches were kept before trial.

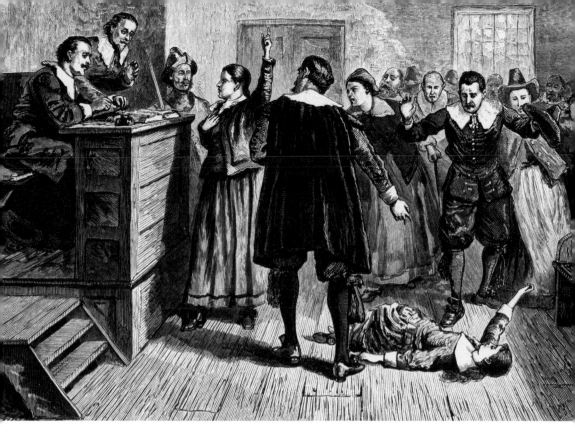

A nineteenth-century depiction of the famous Salem witch trial, later dramatised in *The Crucible* by Arthur Miller.

X

(E)xe Bridges

Crossing the River Exe in days gone by could be a hazardous business. The river was wider than it is now and tidal in both the Roman and Saxon eras (although also shallower) and there seem to have been plenty of accidents as people and horses attempted to cross the river in pursuit of their daily business.

Things changed when mill owner and merchant Nicholas Gervase and his son Walter built a multi-arched stone bridge across the water in 1196. According to some sources, Walter toured the country raising funds from churches and local bishops to finance the construction.

Many now believe a Roman bridge was in existence long before that, but, at any rate, the new bridge was stronger and much appreciated. Construction was delayed for five years by the presence of a female hermit whose home blocked the path. In fact, Nicholas did not live to see the bridge finished, but his son – a future mayor of Exeter – did. The bridge had eighteen arches and was built from Northernhay stone. Many people built their homes on it. There are still remains of the bridge in evidence today. It was the third stone bridge built in England and the oldest surviving medieval arched stone bridge in England.

The view from the bridge leading onto Exeter Quayside.

The western part of the bridge was demolished in Georgian times. After some difficulties, a replacement bridge opened in 1778. This lasted until 1903.

A third bridge was opened in 1905, although plans to replace it were formulated in the 1960s after concerns arose that its presence might be increasing the danger of flooding in St Thomas (as had, indeed, already occurred). No trace of either this or the 1770 bridge now exist. Finally, in 1969, the new north bridge and in 1972 the south bridge opened, both made of concrete.

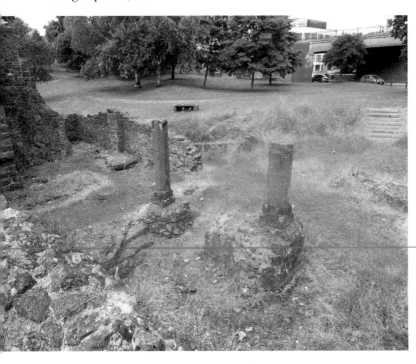

The remains of a wall near Exe Bridges.

Bridges have played a vital role in Exeter's history.

Y

Yorke, Thom

Thom Yorke (b. 1968) studied English and Fine Arts at Exeter from 1988, having already founded the group Radiohead in his native Oxford in 1985. He played music and did some DJing in Exeter. He also met his long-term partner of twenty years during his time as a student, Rachel Owen. Within a few years of Yorke returning to Oxford, Radiohead made it big with a number of hit songs including 'Creep', 'Street Spirit',

Henry's Bar has always been a popular student haunt.

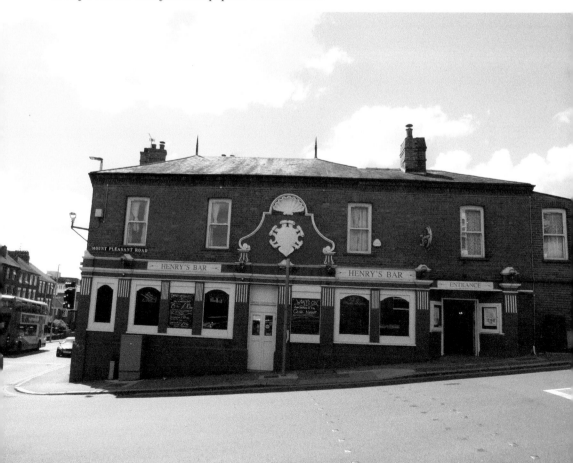

'Paranoid Android' and 'Karma Police' in the 1990s and 2000s. The group's second and third albums, *The Bends* and *OK Computer*, were very well received with some critics hailing them as among the best ever released, if perhaps not the cheeriest.

Young, Will

Born in Wokingham, Will Young (b. 1979) studied Politics at Exeter University between 1998 and 2001 after concluding, 'I thought I should know more about what was going on in my country.' He only received a 2:2. It didn't matter: he soon became a music star after winning TV's *Pop Idol*, beating Gareth Gates. His hits include 'Evergreen' and 'Leave Right Now', as well as a cover version of 'Light My Fire' originally by The Doors. His double A-sided debut single 'Anything Is Possible' and 'Evergreen' was released two weeks after the show's finale and became the fastest-selling debut single in the UK.

Z

Zenith House

This distinctive art deco building in Magdalen Road was built in 1933 and was originally a garage known as Motor Mecca. Although very obviously from the 1930s, it remains an impressive building. Even today, one can get a sense of how exciting this 'all-electric' futuristic construction must have seemed at the time. Later, it fell

Like many 1930s buildings, Zenith House now looks simultaneously very modern and very old fashioned.

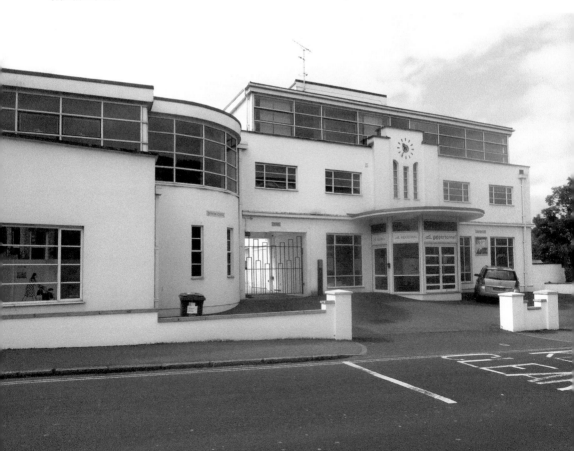

under the ownership of a succession of garage companies, such as the Barton Motor Company, although many locals will remember its long period trading under the name 'Kastner Volvo' between the 1960s and 1990s.

Zenith House has been used as accommodation in the twenty-first century. It remains one of the most interesting looking buildings in the city and as there has never been a zoo in the city, it is virtually the only thing in Exeter to begin with the letter 'z'.

Sources and Acknowledgements

Special thanks first go out to Matthew Beckman for his invaluable contribution to the photography. He displays all the talent and patience necessary to become a great photographer. Well done. Thanks also to Nicky Hallam, the best wife anyone could hope for. Thanks also to my family. I am sorry to have left you behind in Peterborough.

Thanks to Nick Grant, Philip Dean, James Nissler and everyone else at Amberley.

Thanks to Robinson's News, Fore Street, Heavitree, and G. W. Key & Shoe Repairs, Fore Street, Heavitree. Both are among the best and friendliest shops in Exeter. Thanks also to the excellent Daisy Café in Heavitree for helping inspire me.

Thanks to John Groves and the Airfields of Britain Conservation Trust and to Professor Mark Stoyle of Southampton University.

Thanks also to (in no particular order): Tim Isaac, Jim Davis, Colin Bray, Simon Stabler, Dr Derek Edyvane and the magazines *Exeter Life* and *Heavitree News*.

While writing, I have also drawn upon the following books and resources:

Derrick Warren, *Curious Devon* (The History Press, 2008)

Hazel Harvey, *The Story of Exeter* (Phillimore & Co Ltd, 2015)

Tim Isaac and Chris Hallam, *Secret Exeter* (Amberley, 2018)

Tony Lethbridge, *Exeter: History and Guide* (Tempus, 2005)

W. G. Hoskins, *Two Thousand Years in Exeter* (Phillimore & Co. Ltd; Rev. and Updated Ed., 2008)

David Cornforth's Exeter Memories website

Any mistakes are my own.

About the Author

Chris Hallam was born in Peterborough in 1976. He moved to Exeter in 2005 where he now lives with his wife. In addition to writing for many magazines and several children's annuals, Chris is the co-author with Tim Isaac of the book *Secret Exeter*, which is also available from Amberley.